ART IN HISTORY

IDEAS
IN
PROFILE

ART IN HISTORY

600 BC - 2000 AD

MARTIN KEMP

P

PROFILE BOOKS

First published in Great Britain in 2014 by
PROFILE BOOKS LTD
3 Holford Yard
Bevin Way
London WC1X 9HD
www.profilebooks.com

Text copyright © Martin Kemp, 2014
Original illustrations © Cognitive Media Ltd, 2014

COGNI+IVE

ISBN 978 178125 3366
eISBN 978 178283 1020
Enhanced eBook ISBN 978 178 125 4110

The paper this book is printed on is certified by the © 1996 Forest Stewardship Council A.C. (FSC). It is ancient-forest friendly. The printer holds FSC chain of custody SGS-COC-2061

CONTENTS

INTRODUCTION
ART IN HISTORY

The artists and works of art in this book have transformed how art affects us. Over the ages, painters and sculptors have invited us to do radically new things.

To take just one example, we do not know how the first viewers of Diego Velásquez's *Las Meninas* reacted to his mighty canvas, but we can be sure that they had seen nothing like it before. It is recognisable as a group portrait, but does not conform to the norm. The artist is there, but we see only a portion of the back of his painting. The young princess and her entourage have assembled in the grand room. But at whom are they looking? At someone more important than us, we imagine. The king and queen are visible in the mirror. But where are they? They are the absent subject of the picture. Velásquez, in common with other great artists, presents us with a field for interpretation in which we can all play our part.

Art in History concentrates on the triangular relationship between art, artist and spectator – frequently in the context of God and nature. This is how the present book differs from the numerous previous histories of 'Western Art'. It looks at the varied historical notions of art and artists as categories within which art is produced and consumed. What art required of the spectator and what the spectator required of art changed radically over the ages. We will see the artist

emerge as an individual who makes a distinct contribution to the development of art in ancient Greece and again later in the Renaissance. Subsequent centuries witness the evolution of the categories until they assume their modern meanings. The developments often embody the idea of 'progress', a powerful concept in the forging of modern economic and political systems. Indeed, every aspect of the rise of art and artists is deeply involved in material and conceptual shifts in society.

In setting art *in* history, a big question looms into view: is the maker of artefacts a subservient agent or an autonomous hero of creativity? Or to frame more subtle questions: how far is the art work first and foremost an expression of a series of social imperatives; and how far does it depend on the direct and timeless communication of human values from one individual to another? Can it be both of these things? I will argue that the power of images depends on both, in a wholly integrated manner.

How a work of art is embedded in history varies as widely as the works and the artists vary. A medieval Madonna and Child is directly concerned with a kind of spiritual beauty that lies beyond this world, while Goya's painting of a contemporary massacre speaks of violent contention. What we call the 'style' of the work is integral to its effect. The suave grace and high polish of the Madonna would not serve Goya well. The violent colour contrasts and incendiary brushwork of Goya would not exercise the right effect on a medieval worshipper. All the works here demonstrate a compelling unity of style and content. Each of them posits their own special relationship with the spectator in the

context of the society from which they emerged, and they 'speak' to us in a period voice. Although we can still hear them speak, we gain enormously from attuning our ears to their very varied accents.

We will be encountering our key works in a broadly chronological order, because what each artist does is articulated in relation to what went before, and affects our view of the past. As the great poet T. S. Eliot wrote in 1921, 'what happens when a new work of art is created is something that happens simultaneously to all the works of art which preceded it'.

Until comparatively recently, works of art that have emerged from the changing frameworks tell the story of big blokes – whether artists or their funders – and play to what is a familiar story of canonical masterpieces that stood at the centre of new developments in European and North American art. There are of course other stories, but the narrative I follow, looking at European and North American art, is a real and massive one, not least in terms of where the international art world is now, in China no less than in the USA. It is also the story that I am best equipped to tell but I don't claim that it is definitely what the history of art is about. As one of the possible stories, not the least of its attractions is its focus on some of the most enriching works human beings have produced. It is also closely related to what we experience when we step into major galleries and museums.

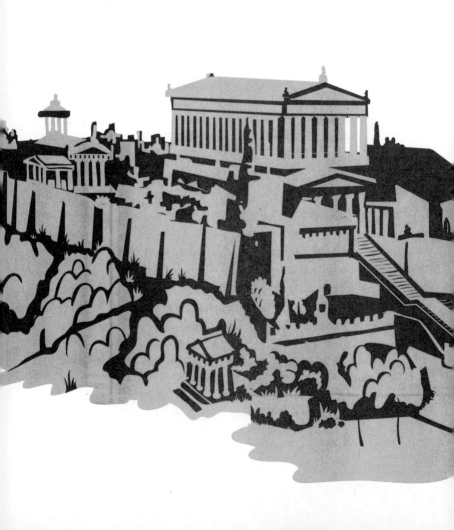

1

THE 'PROGRESS' OF ART
IN GREECE AND ROME

From the *Natural History*, *c.* 79 AD, by the Roman soldier and natural philosopher, Pliny the Elder:

Successive painters' quest for nature and beauty
Apollodorus of Athens, in the ninety-third Olympiad [408 BC] was the first to imitate the appearance of objects, and the first who truly conferred glory on the painter's brush … The gates of art now being thrown open, Zeuxis of Heraclea entered in the fourth year of the ninety-fifth Olympiad, truly destined to lead the brush … to the greatest levels of glory …

Parrhasius of Ephesus also greatly carried things forward, being the first to use proportions in his figures, the first to give animation to faces, elegance to the hair, and beauty to the mouth, and it is recognised by artists that he carried away the palm for contour lines. In painting this is the very highest subtlety. … To be able to create the boundaries and round them off is successfully achieved in art only rarely …

As to Timanthes, he was plentifully gifted with genius [ingenium], and some of the orators have with praise celebrated his Iphigenia, as she stands fatefully at the altar. He painted the grief of all present, and in particular her uncle; but having exhausted all the images of sorrow, ˌ

he veiled the features of the victim's father, unable adequately to represent his feelings … Timanthes is the only one in whose works something more is always conveyed than is actually painted.

It was Apelles of Cos in the hundred and twelfth Olympiad who surpassed all the other painters who came before or after. Single-handedly, he took forward painting more than all the others. Moreover, he published some volumes containing the principles of his art.

With respect to the conscious display of artistry by artists, the ancient Greeks laid the foundations, just as they established all the major branches of modern learning. From the sixth century BC onwards the Greeks were the first (outside China) to lay down a systematic body of recorded thought dealing with the fundamental aspects of human nature, including the soul, and its intersections with the natural and divine worlds. The idealising philosophy of Plato and the nature-based thought of Aristotle set the tone for centuries. Alfred North Whitehead, the twentieth-century mathematician and philosopher, famously declared

that 'the safest general characterisation of the European philosophical tradition is that it consists of a series of footnotes to Plato'. If we include Aristotle, Whitehead's statement becomes eminently supportable. However Plato himself was notably disparaging about visual representation, regarding it as second-hand reflection of the sensory world, which was itself a shadowy manifestation of higher mental and spiritual realities.

The visual arts in Greece were centred on the representation of the human body. They participated in contemporary views about humanity and the gods, granting bodily form to concepts, and in turn shaping the notion of ideal beauty, not least through the artists' own writings. The Roman scholar Pliny noted that the great Apelles wrote on art, as did the fifth-century BC sculptor Polycleitus. In his famous *Canon*, Polycleitus established a system of proportions that comprised the musical mathematics of the parts of the body in the context of the whole. Endowing art with a 'science' – a systematic base in rational knowledge – was and remains a vital component in certifying the status of art and artists alongside other prestigious disciplines. All the Greek treatises on the visual arts are lost, but Pliny, in his extraordinary compilation of everything he considered worth knowing, provides a Roman echo of how the Greek artists regarded themselves and were regarded by others.

Art, for Pliny, arose from the imposition of high culture on physical materials – paint, bronze, marble and so on – involving supreme individual talent (*ingenium* or 'genius'), the imitation of nature, the distillation of beauty, the imaging of the divine, and the conveying of emotion

in narratives. Successive artists contributed to the long march towards perfection, from primitive beginnings to the diverse glories drawn from nature. Painting, for instance, progressed from the tracing of lines around shadows, to full line drawing, to monochrome painting and the addition of shading, followed by the mastery of colours and the scintillation of highlights. .

There are too few surviving works of painting to trace this progression. However, enough sculpture has emerged over the ages, occasionally in the original and more often as later copies, to flesh out the Plinian narrative. This progress is usually shown via a sequence of statues representing a *kouros* (a young man). We can juxtapose an example from

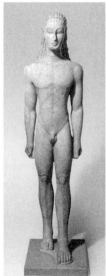 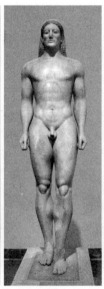 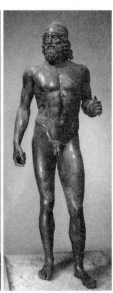

Marble statue of a Kouros,
c. 590–580 BC

Kouros, *c.* 540 BC

Riace Warrior A, 5th century BC

the sixth century BC with one from less than a century later. The earlier *kouros* retains large quotients of Egyptian rectitude, emerging from a rectangular marble block with the planes of front, side and back still very much apparent. Key transitions in the youth's anatomy are delineated as grooves, in keeping with the line drawing described by Pliny. His successor humanises the basic schema with rounded contours, a tremor of flesh and blood and perhaps a hint of a smile. In this instance, very exceptionally, we know the funerary function of the statue. Its inscription instructs us to 'stop and show pity beside the marker of Kroisos, dead, whom, when he was in the front rank [of the troops], raging Ares [Mars] destroyed'. It is likely that each of the *kouroi* and the *korai* (female counterparts) had a specific memorial function, representing the ideal essence of the person commemorated rather than a realistic portrayal.

When a century later we encounter two Greek warriors we find that the communicative presence of the figure has been transformed. The bronze hero's weight (looking at the one known as *Warrior A*) is poised with easy athletic grace. His head turns, his calcite eyes staring assertively, fringed with silver lashes, while his copper lips open in speech, disclosing his silver teeth. Bronze was already an expensive and prestigious material; here it is notably enriched. Beyond a possible memorial function, we know nothing definitive of the identity of the warriors, or their authorship.

Warrior A can be seen generically as a classic hero. He could readily serve as Agamemnon, the tragic hero of the Trojan wars, who had sacrificed his own daughter Iphigenia to the goddess Artemis (Diana), and was murdered by

his adulterous wife on his return. Such heroes, male and military in mien, became god-like in their virtues, while the disputatious gods displayed the human vices of vanity, lust, jealousy and revenge. In the plays of the great Greek tragedians, the human actors are separated from the gods by immortality and power but not by character. The vibrant *Warrior* would need no visible transformation for him to become *Ares* (Mars), the god of war. In a general sense, the warriors are the male embodiments of the self-proclaimed moral virtue and athletic heroism that was valued in Hellenic civilisation, above all in the city-state of Athens. It is worth remembering that the Greek dating system was based on the four-year cycle of the Olympic games.

In the representation of the female form, the ideal envisaged by male fantasy becomes more poetically real than the reality. By no one was this more potently expressed than by Praxiteles, who in the fifth century BC created iconic images of Apollo, Hermes, Artemis and Venus. His *Venus* for Knidos, known like his other masterpieces through later copies, shows the goddess of love after bathing, making an ineffectual gesture of sexual modesty as her hand hovers over her highly idealised genital triangle. The statue was a sensation. During a rapturous account in the *Amores*, a dialogue about love formerly attributed to Lucian, the author declares that 'all her beauty is uncovered and revealed, except in so far as she unobtrusively uses one hand to hide her private parts ... The temple had a door on both sides for the benefit of those also who wish to have a good view of the goddess from behind, so that no part of her be left unadmired'. Of the many later versions, that in Munich gives

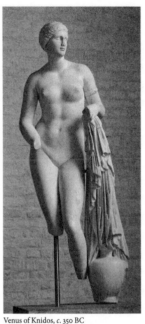

Venus of Knidos, *c.* 350 BC

the best idea of the melting subtlety with which Praxiteles evokes her sexual beauty, envisioned for us yet outside our mortal reach.

Even the most indulgent of the gods commanded respect in the highest places, as on the supremely prestigious pediments of the Parthenon on the lofty Acropolis in Athens. The temple was dedicated to Athena, patron of the city. Her birth from the head of Zeus (Jupiter), fully formed and armed, was displayed in the triangular space of the east pediment, sculpted by Phidias and his workshop in the middle of the fifth century BC. Only the flanking figures have survived. At the end of the left side, the sun rises in the person of a barely emergent Helios in his chariot, drawn upwards by two rearing horses. The other figures are less readily identified but probably represent Dionysus (Bacchus), Demeter, Persephone and Artemis (Diana). Even fractured and eroded clean of their original colour, the marble gods who oversee our fate manifest a remarkable sense of bodily presence, more ideal than our own but compellingly real and alive, whether nakedly male or draped with flowing female garments that serve to define the figures' gracious motion.

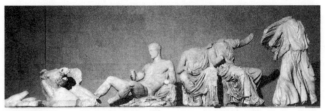

Phidias, East Pediment of the Parthenon, *c.* 445 BC

Later Greek sculpture created striking effects of bodies in vigorous motion. The most famous example is the narrative sculpture of the *Death of Laocoön and his sons* (*Antiphantes and Thymbraeus*), excavated to huge acclaim in Rome in 1506. The tragic story of the Trojan priest is known in a number of varying accounts. The sculpture tells what happens when he tries to warn Troy of the Greeks' ploy with the wooden horse. Athena and Poseidon, who favoured the invaders, dispatch serpents to kill him and his sons. The date of the massive sculpture is much debated, but a consensus seems to be settling on the first century BC.

The powerful bodily torsions and agonised expressions are worthy of the Greek tragedians, whose dramas often tell of resolute heroes suffering the cruellest of divine torments. Virgil, the Roman author, later captured the agonies in his *Aeneid*, where the ravaged priest 'strains to burst the knots with his hands ... while he sends terrible shouts up to the heavens, like the bellowing of a bull that has fled, wounded, from the altar'. The sculpture made a powerful impression on Pliny, who described 'the Laocoön ... in the palace of the Emperor Titus' as 'preferable to any other work in the arts of painting or statuary. It is sculpted from a single block ... This group was made in concert by three supreme artists,

Agesander, Polydorus, and Athenodorus, natives of Rhodes'. It exploits the kind of bodily empathy that later artists in the Christian tradition, particularly Michelangelo, used to convey the severe spiritual and physical suffering imposed on those who were obstinate in their virtue.

As we noted, the painted equivalents of this sculptural narrative have been lost. We catch only glimpses. Perhaps the most spectacular reflection of elaborate Greek painting is the floor mosaic in Pompeii of the *Battle of Alexander*

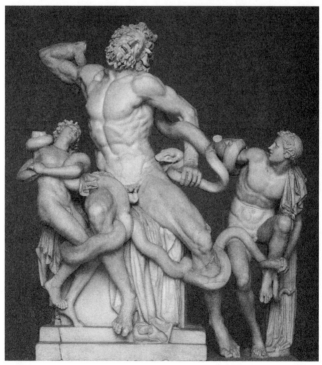

Agesander, Athenedoros, and Polydoros, Death of Laocoön and his Sons, *c.* 50 BC

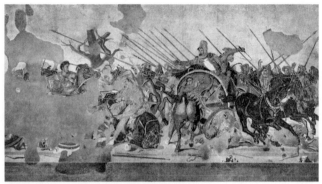

Mosaic of the Battle of Alexander against Darius, *c.* 100 BC

Against Darius. The resolute Greek emperor, in a badly damaged section on the left, steadfastly focuses his attention on the Persian king, who retreats in his chariot through a tilting forest of spears. The bold foreshortenings of the agitated horses, the tangled mass of warriors, the rhetoric of gestures and expressive faces provide a powerful echo of what the Greek narrative painters achieved. It may be a copy of the *Battle* that Pliny describes as painted by Philoxenus for King Cassandra shortly before 300 BC.

By the time that the *Laocoön* was carved, the rising power of the Roman empire, at first republican and then imperial, was submerging that of Greece. The Romans created their own vigorous Latin version of Greek religion and culture, not least in the visual arts, where copies and variants of key masterpieces were produced in considerable numbers. Alongside iconic images, new sculptural genres emerged, such as densely carved sarcophaguses, bronze equestrian monuments, and narrative reliefs on commemorative columns and triumphal arches. Portraiture was a particular

penchant of Roman sculptors, capturing the confident likeness of imperial citizens forging careers in an urbanised and militaristic society. A striking example is the head of an elderly man in the Vatican, identified as someone of civic or religious status by the veil on his bald head. His deeply carved features convey an individual sense of self-conscious gravity. The now anonymous man could well serve as C. Trebatius Testa, to whom the philosopher and politician Cicero wrote in Gaul in 54 BC: ' In the "Trojan Horse", just at the end, you remember the words, "Too late they learn wisdom". You, however, old man, were wise in time'.

Our knowledge of Roman painting is fragmentary but we at least have those miraculous relics from the villas of Pompeii and Herculaneum interred by the eruption of Vesuvius in 79 AD. The surviving wall paintings exhibit a sophisticated command of space and naturalism. The cultivated pleasures of gardens are conveyed with particular delight in the frescoed Garden Room in the Pompeian House of the Golden Bracelet. The murals, painted with delicate energy, extend the relaxing joy of the actual garden into the adjoining space within the house. A tone of licentious pleasure is set by the pillars of a

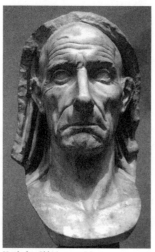

Head of an Old Man, c. 50 BC

maenad on the left (a female companion of Bacchus) and on the right a satyr (a lusty goat-man), each supporting a panel of a woman lounging with erotic intent. Two theatrical masks hang from the top of the aperture, reminding us that the garden of the house serves as a theatre for sensuous pursuits.

During the span of the seven centuries separating the upright *kouros* from the house in Pompeii we have witnessed the rise of the kind of art and artist we later recognise as serving a variety of functions in religious and secular contexts. Overtly secular works in domestic settings, such as the Roman portraits and the Herculaneum frescoes, seem to have occupied an increasing portion of artists' production. We will see a similar trend from the Renaissance onwards.

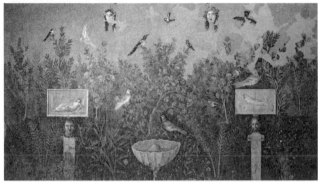

Wall fresco depicting garden and birds, House of the Golden Bracelet, Pompeii

We have witnessed an art of the human body that has risen to expressive extremes of pleasure and pain. And, not least, we have noted the invention of writing about art, telling of how it evolved into a self-conscious pursuit through which patrons and painters could mutually exalt their own status.

2
'GRAVEN IMAGES'

**From 'The Symbolism of Churches and Church Ornaments'
in the *Rationale divinorum officiorum*, c. 1290 AD, by William
Durandus, the Bishop of Mende:**

> *III. 1–4: Pictures and ornaments in churches are the lessons and
> the scriptures for the laity. As [Pope] Gregory declared, it is one
> thing to adore a picture, and another by means of a picture to
> learn historically what should be adored. What writing supplies
> to someone who can read, a picture can supply to someone who
> is unlearned and can only look …*
>
> *Gregory said that pictures are not to be dismissed – in
> order that they should not be worshipped – because paintings
> appear to move the mind more than descriptions. Thus, deeds
> are placed before our eyes in paintings, and so appear to be
> actually occurring, whereas in descriptions, the deed is done as
> it were by hearsay, which affects the mind less when aroused in
> our memory.*

> *I. 24–25: The glass windows in a church are Holy Scriptures,
> which repel the wind and the rain, that is all things hurtful,
> but they transmit the light of the true Sun, that is to say God,
> into the hearts of the faithful. Windows are wider within than
> without, because mystical insight is broader, and precedes the
> literal meaning. Also, by the windows the senses of the body
> are signified, in that they should be closed to the vanities of
> this world, and open to receive spiritual gifts with complete
> freedom.*

By the tracery of the windows, we understand the prophets or other less known teachers in the Church Militant.

When Emperor Constantine converted to Christianity in 312 the role of image-making underwent a huge shift compared to ancient Greece and Rome. According to the most fundamental interpretation of Christian doctrine, there were to be no figurative images at all.

As the medieval writer Durandus later noted, there are six occasions in the Bible when making 'graven images' is explicitly decried. The term 'graven image' corresponds to the Hebrew word for 'idol'. It was idolatrous to worship a physical image made by human hand. Only God should be adored. Key episodes in the Old Testament, most notably Moses's destruction of the golden calf and the establishing of the Ten Commandments, provided the basis of Jewish rejection of images. Early Christian imagery similarly avoided figurative depictions, and chose to resort to signs. The Hebrew YHWH (Yahweh), as the 'tetragrammaton', served as the sign of God the Father's presence. Christ was signified by abbreviations of his Greek name as 'christograms': XP (*chi ro* in Greek), IHC or IHS, or ICX.

Out of this prohibitive climate, Christianity nonetheless developed an elaborate and arcane system of symbolic representation. Over the centuries Christianity progressively succumbed to the age-old need to create 'idols' to support religious devotion – tangible representations to which we attribute spiritual powers. The extraordinary elaboration by which Christian images came to convey

doctrinal meanings was rooted in the need to circumvent the explicit proscriptions in the Bible. Even so, episodes of fundamentalist iconoclasm continued to erupt, in which images were overthrown, mutilated and destroyed. However the incorporation of the Church into traditional structures of Roman-style rulership favoured the use of images as tools of power.

Over the Christian centuries there were a series of moves to legitimise images. Durandus is particularly keen to cite Pope Gregory the Great who wrote two letters around 600 stating what became the standard justification of images – as the illiterate's Bible. Gregory also considered that they could stimulate religious feeling so that devotion was directed towards the subject rather than the representation. Durandus himself described in extraordinary detail how to 'read' every part of a church. He explained the deep meanings not only of the figurative images but also its architecture: wooden beams, for example, signify preachers supporting the Church.

Suppose that there is a mosaic in a church that depicts Christ instructing St Peter to 'feed my sheep'. It can be read at various levels: *literally*, in terms of the immediate story of Christ's instruction, as witnessed by the disciples; *symbolically*, in that the flock of lambs signifies the followers of Christ, himself characterised as the Good Shepherd; *allegorically*, when Christ's instruction is understood to mean that Peter has been appointed to lead the Church; and *anagogically*, according to the highest spiritual interpretation, namely that Peter sits at God's right hand.

Christian art of more than ten centuries bears witness to

an intricate sophistication that far surpasses any ambition to instruct the illiterate.

The fall of the Roman empire – or rather its erratic process of disintegration, transformation, division and partial survival during the course of the fourth and fifth centuries – led to the division of Christianity between a fragile Western empire, centred in Italy, and the powerful Byzantine empire in Constantinople (later Istanbul). The empires developed pictorial traditions that came to transform Roman art in distinctive ways.

The fine mosaic lunette of *The Good Shepherd* in the so-called Mausoleum of Galla Placidia in Ravenna, which served as the capital of the Western empire from 401 until 476, exhibits deliberate echoes of Roman art. The beardless Christ sits in a rocky landscape like Orpheus among the animals, commanding his flock with a cross rather than his shepherd's crook. The sheep adopt a variety of artistic poses and are quite skilfully foreshortened. The durable medium of mosaic, composed from *tesserae* of coloured glass and

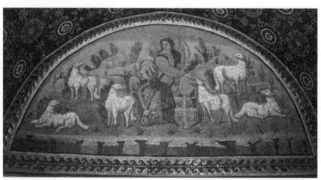

Ravanna, *The Good Shepherd*, c. 425

other materials, is now used for walls rather than floors. The reflective facets are set at varied angles so that the surface shimmers in a visionary manner within the vaulted confines of the smallish, cross-shaped building.

With the fall of the Western empire and its eventual reconquest by the Eastern emperor, Justinian, in the mid-sixth century, Byzantine supremacy was consolidated over what remained of the Roman territories, constituting a Mediterranean and Near Eastern empire that endured for more than a thousand years. In Constantinople the Roman-ising tendencies were suppressed by two major episodes of fractious iconoclasm from about 726 to 787 and 814 to 842. The summary of an iconoclast council in 754 declared that 'Satan misled men, so that they worshipped the creature instead of the Creator. The Law of Moses and the Prophets cooperated to remove this ruin … But the above-mentioned demiurge of evil … gradually brought back idolatry under the appearance of Christianity'. Accordingly, the council decreed that the Church destroy 'every likeness which is made out of any material and colour whatever by the evil art of painters.' Matters were, however, more or less resolved in favour of image-making in 842, when a synod convened in Constantinople marched to the great church (now mosque) of Hagia Sophia to reinstate images, an act still commemo-rated by the Orthodox Church.

The main kinds of images that were reinstated in the Eastern Orthodox Church were what are now known as 'icons' (which is simply Greek for images). As represented by the famous '*Icon of Vladimir*', the style is gloriously non-naturalistic, with assertively flat shapes denoting

otherworldly bodies, hands, faces and draperies, against burnished gold backgrounds. Painted in tempera (using egg as a binder) and richly ornamented, its 'artistic' quality may be compromised by restoration but its spiritual potency remains. This miracle-working icon assumed legendary status. Around 1131 the Patriarch of Constantinople dispatched the finely painted icon to Kiev. It is reported that the

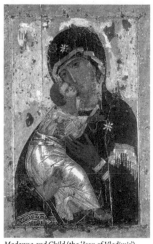

Madonna and Child (the '*Icon of Vladimir*'), *c.*1130

horses transporting the panel stopped near Vladimir and refused to move. The Assumption Cathedral in Vladimir was built specifically to house the image.

The representation does not look 'real' compared to works from classical antiquity. Its reality exists on another level for worshippers. The icon asserts the Virgin's presence as the *Theotokos* ('Birth-giver of God'). Ascended to heaven, the immaculate Mary does not follow the rules of this world but adopts an eternal and unchanging guise within a non-specific space. Her solemn stare grants no escape from spiritual imperatives.

The presentation, with mother and child cheek to cheek, is one of a small series of Madonna-and-Child types that are endlessly repeated, regardless of date and geography. This is simply *the* Virgin. She does not look like us; she

is not in our realm; she is not of our time or of any time; her spirit is effectively present, if not exactly *in* the image but transcendentally discernible *through* it. The painter responsible may well have been admired for his high levels of skill, and sometimes for inventing new variations on stock themes, but he is simply a means through which the image is realised, not an individual 'artist' with a personal style. When Eastern Orthodox worshippers were later confronted with naturalistic European paintings of saints by artists brandishing individual styles, they could not pay due devotion to them.

The complex fluctuations of power in Europe after the fall of Rome, and the rise of the Carolingian empire of the Franks in the ninth century, was accompanied by the extensive spread of Christianity. Some regional religious centres offered stability for cultural expression at the highest level. Supreme examples of the visual and intellectual quality of 'regional' art are the magnificent Celtic illuminated manuscripts, the Lindisfarne Gospels, the Book of Kells and the Book of Durrow, together with virtuoso metalwork and stone crosses, produced in centres of monkish activity in Ireland and Northumbria. Celtic art of the Christian era may be provincial in origin but it is international in sophistication.

The *Chi-Rho* page in the Book of Kells presents an extraordinary feast for the eye. It opens the account in the Book of Matthew of the miraculous generation (*generatio*) of Christ (*XP*). Knotted interlaces weave dense patterns of intricate visual music around letters, interspersed with lovingly stylised figures, heads, animals and plants. This

is art for sustained contemplation. The twelfth-century chronicler, Gerald of Wales, captured what was required of the observer:

> Here you may see the face of Divine Majesty, mystically drawn, here the mystic symbols of the Evangelists … here is the eagle, there the calf, here the face of a man and there the

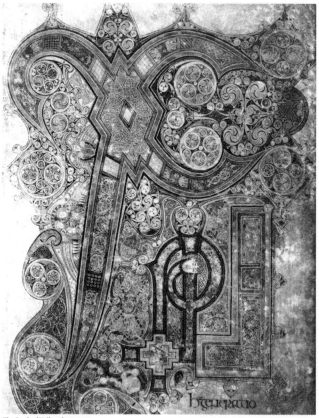

The Book of Kells, 8th century

lion, and other forms almost infinite in variety. Look at them superficially in the ordinary casual manner, and you would think them to be daubs, not intricate compositions ... Look more closely and you will penetrate to the very shrine of art in these pictures. You will make out intricacies, so delicate and subtle, so finely drawn, so full of elaborate interlacing, with colours so fresh and vivid, that you might say that all this was the work of angelic rather than human skill.

All the figurative presentations in the book, whether of the Virgin and Child, the Evangelists and their symbols or the many angels, are subjugated to a series of curvilinear stylisations of great beauty, without the danger of producing realistic 'idols'. Sensory delight is intended to serve as a ladder to heavenly contemplation.

As the Church became institutionalised across Europe, Christian devotion came to accommodate 'spiritual magic' embodied in images and objects. This is vividly apparent in reliquaries, containers for remains of a divine person, perhaps a bone, which was venerated in its own right and endowed with therapeutic powers. The containers assumed devotional magnificence as figurative images of the saint. The Abbey at Conques

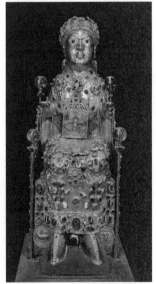

Reliquary Statue of Sainte Foy, c. 900

in France dubiously managed to acquire the skull of Sainte Foy, a fourth-century martyr – to such good effect that the pilgrimage route was diverted through the town. The magnificent reliquary, consisting of a shell of gold plates over a wooden body, resulted from a process of accretion. The golden face originates from much earlier, and the enthroned figure has been progressively adorned with precious stones and rock-crystal orbs.

Unsurprisingly, the veneration of such a sumptuous 'graven image', almost three feet tall, needed defending. Bernard of Angers, recounting the many miracles of Sainte Foy, explained that 'it is not an impure idol that receives the worship … It is a pious memorial, before which the faithful heart feels more easily and more strongly touched by solemnity, and implores more fervently the powerful intercession of the saint for its sins.'

As the Papacy consolidated worldly power, primarily at Rome but with interludes elsewhere, it stood at the centre of that grand network of diverse and unruly elements comprising

CATHEDRAL BASILICA OF OUR LADY OF CHARTRES
1194–1250

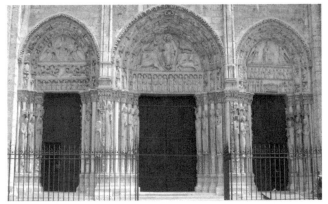

Chartres, Central West Portal (the 'Royal Portal'), c.1225–40

the Western Church. Its majesty is evident in its buildings. Europe is still punctuated by great cathedrals, abbeys and churches, sponsored by the Church, monastic orders, autocratic rulers, civic authorities and, in later periods, by rich private individuals. Huge investments were made in booking a passage into heaven.

The decoration of the magnificent Cathedral at Chartres, south-west of Paris, gives a good idea of the scale and quality of medieval church decoration. The Cathedral boasted its own much-venerated relic, the Sancta Camisa, the tunic worn by the Virgin at Christ's birth. Sculptural decoration inside and outside was intended to create awe. The wide central portal at the East entrance is dominated by Christ in judgemental majesty, accompanied by the symbols of the four Evangelists. He is surrounded by an arched array of the enthroned Elders of the Book of Revelation, and sits above an arcade occupied by standing Disciples. Flanking the door are austerely columnar kings and queens who represent the

royal lineage of Christ in the Old Testament. Every element speaks of authority, superbly designed to act in disciplined concert within the grand architectural frame rather than with naturalistic appeal.

Gothic art – the 'art of the Goths' – was originally a term of abuse, but has come to be synonymous with the dominance of Christian painting, stained glass, sculpture, metalwork and architecture from 1200 onwards, in intricate, adventurous and often linear styles that were generally distinct from ancient classicism, even when they looked back to Rome for inspiration. Gothic art came to embrace wide varieties of figure types that gained increasing degrees of independence in motion and characterisation. The range

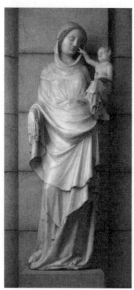

Virgin and Child, c.1345

stretched from exaggerated grotesque to ultra-refined. At the most elegant end of the design spectrum are high Gothic sculptures devoted to the cult of the Virgin. A particularly suave example is the *Madonna and Child* from the *béguinage* or 'convent' of St Catherine in Belgium. The *Beguines* were lay sisters, and it was a Sister Superior who paid for the fine carving in an alabaster-like marble. Those who prayed to this gently smiling Virgin were granted twenty days indulgence from punishment for their sins.

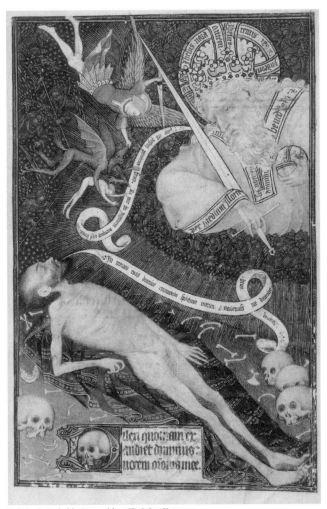

Fight for the Soul of the Deceased from *The Rohan Hours*, 1430

Originally gilded in part, the sculpture is the epitome of elegance in the orchestrated curves of its drapery and the easy grace with which Mary supports her small child, who touches her cheek, perhaps to acknowledge that he is of her flesh.

In Christian theology the sweetness of redemption and the spectre of punishment went hand in hand. The hope of redemption is narrated in a vivid illustration in a Book of Hours probably commissioned by the widow of the Duke of Anjou. We are witnessing the fight for the soul of a deceased and emaciated man in a field of bones. He may stand for the Duchess's dead husband. He announces in Latin, 'into your hands, O Lord, I commend my spirit. You have redeemed me, O Lord, God of truth'. God the Father, holding a sword and orb of the world, instructs him in French: 'do penance for thy sins, and thou shalt be with me at the Judgment'. A winged demon has already seized the man's pale soul as it departs his body, but St Michael swoops down to effect an armed rescue.

A typical Book of Hours, the most prominent type of later medieval manuscript, contained specially selected sacred texts and prayers, including offerings for the dead. Laypersons used the texts to articulate their devotions, emulating the daily regimen of monasteries and convents. For wealthy patrons the book's vellum pages were illuminated in the richest manner. As luxury products, they exuded virtuosic artistry, a developed sense of dramatic composition and expressive detail. We may well imagine that the owners saw no conflict between expensive connoisseurship and elevated piety.

The flowering of the late Gothic in the fifteenth century in no way conforms to the idea of the last gasp of a fading style. It reflects the increase in the private wealth of a regional elite, for whom the commissioning of stylish works in the finest materials became a sign of their status.

A splendid example is the *Tomb of Richard de Beauchamp, Earl of Warwick* in the Church of St Mary in Warwick. Richard rose to positions of prominence in the military, diplomatic and civil service of kings Henry IV, V and VI. He acquired considerable booty during English conquests in France, and was the captain of Rouen during the captivity and execution of Joan of Arc. It was in Rouen that he died in 1439, leaving money to build a chapel at St Mary's and to

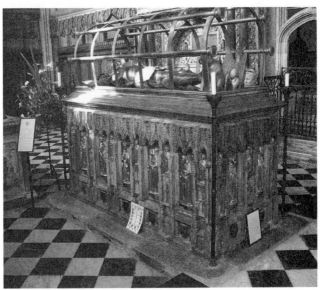

Tomb of Richard de Beauchamp, 1448–53

erect a notably expensive monument. We know the names of the craftsmen who worked on the tomb between 1448 and 1453. They included: William Austen of London, who produced the effigy; John Massingham and John Essex, who carved the Purbeck marble; Barthilimew Lambespring who worked as goldsmith; and Thomas Stevyns, who served as coppersmith. If they are not quite 'artists' in the ancient or Renaissance sense, they clearly had high reputations. While there are signatures on medieval works of art, such pride does not yet signal the kind of personalised 'authorship' of the Renaissance. The list of names and responsibilities gives some idea of the lavishness with which materials were used in the ensemble. Under the arched canopy lies the chivalric knight in shining copper-gilt, with a heraldic griffin and bear at his feet. Below are alternating rows of gilded mourners and melancholy angels, set in elaborate late Gothic niches. The array of heraldic shields of English nobles under the mourners are coloured in enamel. From his French adventures Richard was well acquainted with visual glories commissioned by Burgundian nobles: he was not to be outdone.

Circumstances surrounding our second example of courtly late Gothic are more obscure. The famous set of seven tapestries of the *Hunt of the Unicorn* in New York is first recorded in the seventeenth century. It is possible that the tapestries were commissioned to mark the marriage of Anne of Brittany to King Louis XII in 1499 and were probably woven in the Southern Netherlands. Legends had grown around the one-horned beast since antiquity. It was famously immune from capture by hunters, which

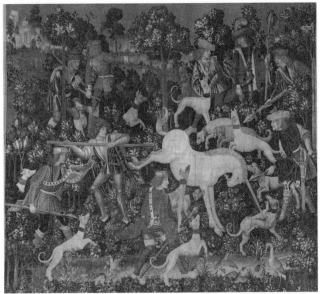

The Unicorn Fights off the Hunters, c. 1500

they attempt to accomplish in the fourth scene, shown here. However, the unicorn could be readily ensnared by a virgin, as happens in the fragmentary fifth tapestry. Once the virgin wins her trophy, the hunters complete its capture and slaughter. The purifying activities of the unicorn, its intimate association with a virgin, and its eventual death are woven into an elaborate web of meaning: the creature becomes a symbol of Christ.

The unicorn's valiant fight is portrayed with decorative and chivalric panache. Courtly hunters and their leaping hounds converge on the prey through a forest into a flower-decked clearing. The tapestry is luxuriously woven from wool, silk, silver and gold, combining to enchant the viewer.

The observational naturalism of the details, especially the precisely characterised species of plants, is especially eye-catching.

The tapestry dates from around 1500. By this time the career of Michelangelo was well under way. The next chapter, dealing with what we call the Renaissance, begins almost 200 years earlier. Are we dealing here with some kind of sumptuous late Gothic hangover in Northern Europe, awaiting replacement by a more modern or advanced style? If we take naturalism as the criterion of the modern Renaissance style, we should ask what kind of naturalism. If we mean a dedicated attention to the specificity of the appearance of things in nature, the tapestry is more 'advanced' than its Italian counterparts. Indeed, Italian patrons looked north when they wanted the best tapestries. If we mean a measured illusion of optically constructed space, it is to Italy that we have to look. In terms of reading God's 'book of nature', the northern worship of specific plants and animals was highly effective. For the mathematics of God's underlying design, we look to the sciences of perspective and proportion as developed in Italy in the fifteenth century.

Taking Gothic to mean old-fashioned and Renaissance to mean up to date skews our view of art in history. The way we conveniently package art within neat periods is too simple. We can too easily be trapped by such terms, endowing them with some superior reality. Labels both inform and distort our ways of looking.

Looking back to classical antiquity and forward to the Renaissance, we can see that there is a decisive difference in the production of art in the medieval period. This difference lies in the coupled notions of 'art' and 'artists', which developed in ancient Greece and which came to stand at the heart of the Renaissance. This chapter has largely been devoid of artists' names, and we have not witnessed any discussion of 'art' as an activity in itself. Durandus was well capable of recognising great artistry, but the function of art was not to promote the individual genius of its makers or to establish its own criteria of value independently of the function of each artefact. 'Graven images' were things to be seen *through* rather than admired as ends in themselves.

3

THE RENAISSANCE AND 'PROGRESS' AGAIN: 1300–1600

From the *Lives of the Most Eminent Painters, Sculptors and Architects*, 1568, by Giorgio Vasari, painter and architect:

Introduction to Part 3: the three ages of art

Draughtsmanship consists of the imitation of the most beautiful parts of nature for all figures whether in sculpture or painting; and this quality depends on the ability of the artist's hand and genius to record what he sees with his eyes …

Style achieves the highest beauty from the copying of the most beautiful objects in nature and combining the most perfect things, hands, head, torso, and legs, to produce a figure of the greatest possible beauty …

These things had not been done by Giotto or the other craftsmen of the first age, although they did discover the basic principles for solving artistic problems … Their drawing, for example, was more true to nature than anything done previously, as was the harmony of their colours, the composition of their figures in narratives, and many other things …

Although the masters of the second age further augmented our arts with respect to all the features mentioned above, these were not so developed as to achieve complete perfection …

Then we encounter those who saw some of the most famous antiquities mentioned by Pliny excavated from the earth: namely, the Laocoon, the Hercules, the great torso of Belvedere, as well as the Venus, the Cleopatra, the Apollo, and countless others …

Leonardo … originated the third style that we propose to term the modern; for in addition to the vivacity and boldness of his draughtsmanship and his subtle and exact reproduction of all the minute aspects of nature – just as they are – he displayed in his works good rule, correct order, perfect draughtsmanship, and divine grace.

The period we know as the 'Rebirth', the Renaissance – the revival of art and learning supposedly lost since ancient Greece and Rome – saw the adoption and development of key notions about visual art and the role of artists we first encountered in Pliny. Not the least significant was the idea of progress, in which a succession of great individual artists is part of art's march towards mature perfection. Within this pattern, there is room for each artist to exhibit their own particular qualities. Another Plinian notion that took powerful hold was that of 'fame' as a goal towards which

artists should strive. Perhaps the dominant characteristic Pliny shares with Renaissance art is the quest for naturalism, driven by a conviction that art should imitate nature. This imitation, as we will see, took many forms, depending on what was meant by imitation and understood as nature. A powerful force behind this development was Humanism, the literary and philosophical movement that aspired to revive ancient Latin learning. It brought with it the criteria for idealised naturalism as advocated in ancient art theory.

One artist who embodies the rise of these notions is Giotto di Bondone, the hero of Vasari's first age. The Florentine painter and architect became recognised as a 'great man',

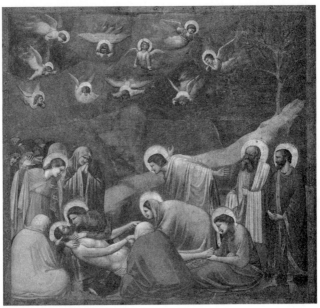

Giotto, *Lamentation of Christ, c.* 1303–6

the point of reference whenever learned writers alluded to artistic 'genius', the imitation of nature or the revival of ancient painting. Giotto's fresco of the *Lamentation of Christ* is one of a series of narrative scenes painted in an oratory in Padua, financed by Enrico degli Scrovegni, a rich merchant. Investing in the eternal life of his soul, Enrico may have had in mind the biblical injunction that it is easier for a camel to pass through the eye of a needle than for a rich man to enter heaven.

The powerfully modelled figures act out the dramatic 'history' in a compact frieze, and one of the mourners throws out his hands in the way we see on ancient sarcophagi. The women react with wrenching intensity, while the two men to the right manifest stoic resignation. The writhing angels in the sky act out varieties of grief with unrivalled rhetorical power. The two monolithic mourners with their backs to us, whose robes bunch up against the lower border of the fresco, serve to lock in the emotion, allowing us to impute the kind of grief that Pliny inferred in Timanthes' painting of the *Death of Iphigenia*. Such vivid storytelling corresponds to contemporary writing on the life of Christ, in which the reader was asked to visualise his or her presence at the sacred events.

Giotto's circumstances in Padua, working for a money man in a major university city, are symptomatic of two great tendencies in the period. There was the new kind of civic society – driven by the early capitalism of merchants, bankers, politicians and tyrants – that found dynamic expression in Italian city-states. This was coupled with the rise of humanism, the literary and philosophical movement

that looked towards the intellectual models of antiquity.

These new ideals are depicted in a large fresco in Siena's Palazzo Pubblico of a city under good government, painted by Ambrogio Lorenzetti, the greatest painter of the post-Giotto generation. People of various classes go about their proper business – builders build, traders trade, teachers teach and horses cart provisions. The group of dancing maidens (or perhaps male performers) is an artificial insertion into the everyday townscape to underscore the harmony of the well-ordered city. Clusters of buildings – civic, ecclesiastical, commercial, private and defensive – stress the mutual dependence of every component in a modern society. Adjoining the city zone of the fresco is the extra-mural countryside. While urban hunters leave from the city gate, rich provisions flow in.

In Vasari's second age, almost a century later, this sense of orderly space is transformed into compact form in Masaccio's remarkable wall painting of *The Trinity with Donors* in the Florentine church of Santa Maria Novella. The young painter, who was to die at the age of 27, shows

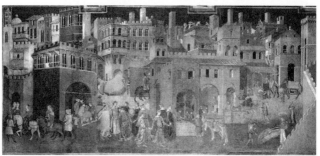

Lorenzetti, *The City under Good Government*, 1338–9

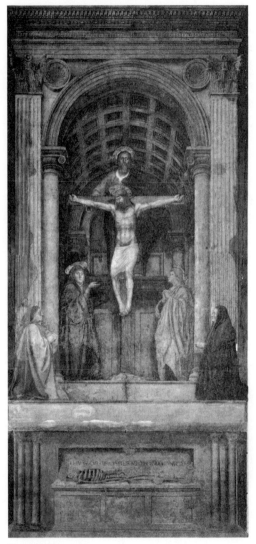

Masaccio, *Trinity*, c.1526–7

a prominent citizen and his wife praying for their souls to the Virgin and St John, who in turn address the crucified Christ, the dove of the Holy Spirit and God the Father. Masaccio's rather damaged fresco is an assertion of the new science of perspective, which dictates the forceful recession of the vault towards a single 'vanishing point'.

Masaccio's older colleague, the architect Filippo Brunelleschi, had invented a form of linear perspective some years earlier, which he displayed in two painted demonstration panels of Florentine buildings. Masaccio saw how Brunelleschi's method could be adapted to religious subjects. The basic rules of geometrical perspective were codified in a short book *On Painting* by the humanist intellectual and architect Leon Battista Alberti. The Latin text of 1435 was translated into Italian a year later and dedicated to Brunelleschi. Having demonstrated how to lay out a perspectival stage for his pictorial actors, Alberti tells us how to compose eloquent narratives and establishes the high social value of the painter's art. Modern art now had a theory of its own.

Masaccio uses a hierarchy of perspectival depth to complement the vertical hierarchy of the figures. At the lowest level in our earth-bound space is a macabre skeleton that reminds us, 'I was once what you are, and what I am you will become'. The pious donors kneel higher in the same space. Our vision then passes through the wall's plane into the illusionistic space reserved for divine beings. Perspective's spiritual potential is realised with instant maturity.

Working alongside Brunelleschi and Masaccio was Donatello, the most prominent of the innovatory sculptors

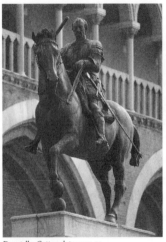

Donatello, *Gattamelata*, 1443–53

in Florence. He translated the ancient art into forms serving new kinds of civic and ecclesiastical ambition. In 1443 Donatello moved to Padua for a challenging commission of a bronze equestrian memorial to the deceased military commander, Erasmo da Narni. Equestrian statues were not unfamiliar in north Italy, but to produce one in expensive and technically demanding bronze was exceptional, and consciously looked back to Roman exemplars. Erasmo, the mercenary general, brandishes his baton of command, signifying the power his Venetian employers exercised over Padua. The soldier's sober head is modelled on Roman portrait busts, and his costume is conflated from medieval armour and ancient decorative motifs. His warhorse, with its raised hoof supported structurally on the orb of the world, exudes muscular grandeur in marked contrast to sprightly Roman precedents. Vasari was so impressed by Donatello that he was tempted to grant him honorary membership of the third age.

The great bronze stands high on a pedestal outside the pilgrimage church of Sant'Antonio in Padua. Inside, Donatello was occupied in constructing the high altar as a bronze tableau of the Virgin and Saints. In Padua, we see, in close

juxtaposition, innovative and costly Renaissance art serving the complementary needs of State and Church –financed by wealthy private individuals.

In mercantile Bruges in the Netherlands the integration of rising civic ideals and existing religious imperatives was no less apparent than in Florence and Padua. Italians were well represented in this northern trade city, and one of their number, a Florentine merchant from the Arnolfini family, was portrayed with his wife by Jan van Eyck. There were three known members of the Arnolfini family in Bruges called Giovanni. The most likely candidate is Giovanni di Nicolao Arnolfini. However, his wife Costanza Trenza died in 1433, and the painting is dated 1434, suggesting that it could be a memorial to their union. Portraits were often occasioned by specific events, including death. The problem is that Jan's painting is so exceptional we cannot rely upon comparable images to understand why it was painted.

The couple stand hand in hand in a fine bedchamber, painted with great optical conviction – even though the perspective does not exhibit a single 'vanishing point'. Jan gives the medium of oil paint a new descriptive power. The painted light passes almost tangibly through the enclosed space, casting shadows, gleaming on glass and polished metal, and caressing surfaces into varied textures. Symbolic details, such as the single candle burning to extinction in the ornate chandelier and the convex mirror, are integrated into the naturalistic fabric of the painting. Remarkably, the painter has added a calligraphic graffito on the wall above the mirror: 'Jan van Eyck was here, 1434'. We are asked to assume that Jan is one of the witnesses seen in the mirror.

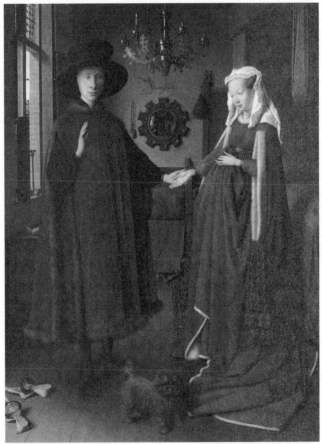

Jan van Eyck, *The Arnolfini Wedding*, 1434

This level of self-consciousness is as great as that of contemporary Italy. We know that Jan was regarded as both a great painter and a citizen of high status, serving the Duke of Burgundy as a trusted diplomat.

As it became better known, the Netherlandish technique

of oil painting caused a sensation in Italy, at least in terms of light, colour, shade and descriptive detail – though not with respect to figure style and perspective. The most profound early response was in the 'Serene Republic' of Venice, that miraculous sea-born city of reflecting canals, fretted facades and sparkling mosaics. Giovanni Bellini established expectations about the vivid role of colour that were to dominate Venetian art for centuries.

Bellini's *St Francis* sets the tone. Large enough to be a small altarpiece, its asymmetrical composition suggests some other purpose. It might have been commissioned for a private palace as an item of wonder. Its precise subject matter is elusive. St Francis is frequently shown receiving

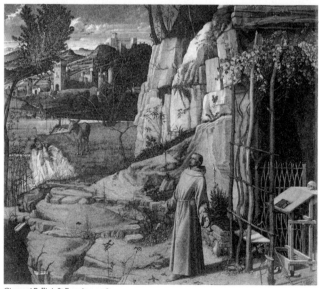

Giovanni Bellini, *St Francis, c.* 1478

the stigmata in his hands and feet on Monte La Verna, but the composition does not correspond to the known narrative. Rather, the saint has stepped outside his penitential cave, past the perspectival trellis and leaving behind his sacred book, cross, crown of thorns, skull, and sandals – seemingly to greet the radiant light of morning. We might think of the saint's 'Canticle to the Sun'. However, he is actually looking with open-mouthed awe at a specific stream of light from the upper left. The angle of the light, which seems to bend the laurel tree to its will, is defined by the saint's shadow, and is subtly differentiated from the sunlight.

There may be no definite written source for the painting. Rather, Bellini evokes the saint's spiritual rapture in a landscape manifesting the glory of creation, his privileged reception of divine visions, his humble retreat from the worldly concerns of the city, his stigmatisation, and his surrender to divine will. One of Bellini's contacts stated that he 'does not like to be given many written details, which cramp his style. His way of working, as he says, is always to wander at will in his pictures'. What Bellini has created in his *St Francis* is a wonderfully engaging journey for eye and imagination.

The resonant optical effects of oil paint were taken to new levels of imaginative suggestiveness by Leonardo da Vinci, whose training under the sculptor favoured by the Medici family, Andrea Verrocchio, placed him in the succession of Donatello. Leonardo, harbinger of the third age, radically built upon the Florentine tradition of the science of art. The optics of painting was extended from the geometry of light to the ways that the eye and brain function in acts of seeing.

LEONARDO DA VINCI
RENAISSANCE MAN 1452 – 1519

Anatomy was extended from scrutiny of bones and muscles into the processes of thinking and reacting. The delineation of structures in landscape was extended into a profound vision of the ancient history of the 'body of the earth'. The job of the artist became to re-make nature – just as Leonardo the engineer constructed mechanical devices on the basis of natural law. Painting was re-envisaged as an expression of natural philosophy in the tradition of Aristotle.

The so-called *Mona Lisa* embodies these principles. Ostensibly it is a portrait of Madonna Lisa del Giocondo,

the wife of a Florentine silk merchant, begun in 1503. As an image of an enigmatic beloved lady, it is fully in keeping with love poetry in the tradition of Dante. Over the long years of its execution, it evolved into a statement about painting as the supreme expression of the human being as a microcosm – as a world in miniature. The flow of her hair, the spiral current of her scarf and the rivulets of drapery in her dress (and by implication the motion of air and blood within her body) resonate with motions of water in the flesh and bones of the landscape.

The painting also develops into a hymn of indefinite vision, as Leonardo increasingly realised the complexities of acts of seeing. Around 1507 he wrote that 'the eye does not know the edge of any body'. He applied oil paint with wondrous delicacy, sometimes resorting to small propor-

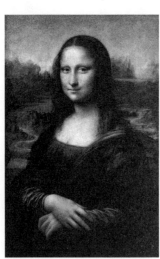

tions of pigment in the oil binder to create veiled effects of light, shade and colour. This indefiniteness works with the female sitter's direct glance and half-smile – daring motifs – to invite our imaginations into the image, teasing us with the promise of an optical and psychological definition that remains perpetually elusive. It is this teasing openness that explains all the endless,

da Vinci, *Portrait of Lisa del Giocondo* (the '*Mona Lisa*') 1503–16

often crazy attempts to identify the sitter as someone more obviously exceptional than Lisa and to diagnose her secrets. The secrets are those that we bring to it. A new kind of artistic communication has been born.

When Leonardo returned to Florence from Milan in 1500, he collided with an artist some 23 years younger, Michelangelo Buonarroti, son of a prominent family and protégé of the Medici, and someone deeply affected by Neo-Platonic philosophy. Leonardo was one of the state 'committee' asked to recommend where to place the marble 'Giant', Michelangelo's *David*. The massive 17-foot marble block had lain in a workshop for more than 25 years, 'badly blocked out' by an earlier sculptor. Michelangelo saw how to extract a figure from the marble.

Naked, like Donatello's much smaller bronze *David* for the Medici, Michelangelo's statue combines the biblical hero's athleticism with the divine resolution that allowed him to defeat Goliath. David's leonine hair, stern frown, taut anatomy and mighty hands underscore a level of self-sufficiency that reflects the Florentine republic's self-image. David had, after all, discarded the armour offered by Saul, electing to go into battle with just his sling. This self-sufficiency was integral to Michelangelo's own sense of identity: 'David with his sling; I with my bow', as he wrote on a drawing for the Old Testament figure. The bow is the sculptor's bow drill.

Vasari's third age had arrived, and with it a confidence that emulating the art of classical antiquity was no longer the limit of aspiration. Rather, antiquity could be surpassed by artists working on their own terms in contemporary

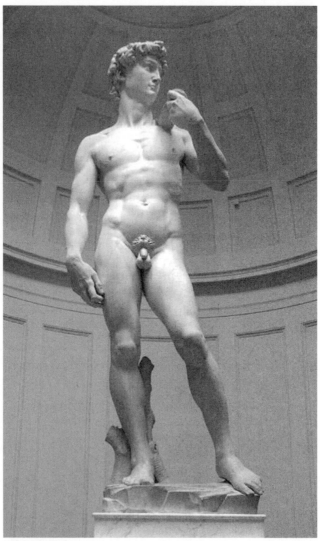

Michelangelo, *David*, 1501–4

society. A small cadre of leading artists, including the young Raphael, was also concerned with status and even immortal fame. They became more disinclined to follow patrons' diktats. Michelangelo's turbulent relationship with Pope Julius II in Rome was typical. Although Michelangelo finally agreed to painting the Sistine Chapel ceiling, the artist's creative impulses had freer reign than would have been possible a generation before.

Albrecht Dürer, the great German contemporary of Leonardo, recognised this when he visited Venice. He wrote, 'here I am a gentleman, at home a parasite'. By 'parasite' he meant a workman who scrounged a living off others. This was written on his second visit in 1505–7, where his grandest public commission was for the *Madonna of the Rosary* (or *Feast of the Rose Garlands*), commissioned by the merchant and banker Joseph Fugger on behalf of the city's German community. The unified field of the altarpiece, in which donors and holy figures convene under the aegis of the Queen of Heaven, conforms to the most advanced Renaissance format, while the colouristic brilliance pays homage to his Venetian contemporaries, above all Giovanni Bellini.

The Holy Roman Emperor, Maximilian, is accorded a crown of roses by the Virgin on the right, while the tonsured Pope Julius is to be comparably crowned by Jesus. Among the other attendant worthies, we can identify Fugger fingering his rosary beads behind the emperor, while directly above him Dürer himself stares directly at us, holding a sheet of paper on which he has written, 'executed in the space of 5 months by Albertus Dürer the German'. His somewhat exaggerated claims for speedy execution confirm

Dürer, *Madonna of the Rosary*, 1506

our impression that this was both a functional image with complex meanings and a pictorial demonstration piece. His remarkable body of woodcuts and engravings, each signed conspicuously with his monogram, spread his personal fame across Europe.

Dürer's self-awareness extends to his production of the first-ever series of painted and drawn self-portraits, and his published writings on geometry and human proportion, which demonstrate an awareness of Leonardo's unfulfilled ambitions to complete treatises on the intellectual foundations of art. Dürer's book on geometry, originally written in German, was widely influential beyond art.

On his second visit to Venice, Dürer was aware of the rise of a new generation, headed by Giorgione and Titian,

though he continued to prefer Bellini. Like Leonardo, though in a different way, the new boys were beginning to exploit a less definite manner of painting with oil. They used a freer, painterly style, with looser brushwork, often on canvas rather than panel. The paint becomes apparent as paint and suggests rather than defines shapes and colours.

Giorgione is now identified with smaller-scale paintings, whereas in his lifetime he was famed for exterior murals, especially those on the Fondaco dei Tedeschi (the German merchants' warehouse) on the Grand Canal. Vasari, when he later visited Venice, admitted that the figures on the facade were 'very well done and coloured in the most lively

manner', but he could not make out their subject matter. Giorgione, he wrote, 'thought of nothing other than to paint figures according to his own imagination in order to demonstrate his high talent … and, for my part, I have never understood their meaning, nor have I, after asking around, discovered what he intended.' It is unlikely that the figures had no representative function, but their meaning appears to have been deliberately suggestive.

This typically open quality characterises Giorgione's most famous painting, the *Tempesta*. Efforts to find a literary source have foundered. The earliest description of the painting as 'a little landscape on canvas with a storm and a gypsy with a soldier' suggests that its precise content was not evident at the time. It appears to be improvised in the manner of a musical fantasia, as an imagined depiction of a fancy youth observing a near-naked mother suckling a baby in a sylvan glade. If there is a prescribed story, it is obscure enough to leave room for us to 'wander at will', as Bellini wished. Compared to Bellini's more encyclopedic account of the detailed wonders of nature, Giorgione subsumes the particular within the overall mood, the colouristic effect of the encroaching storm, and the painterly fabric of the picture's execution.

Giorgione's career was cut short by his early death in 1510, but Titian lived until 1576, not only taking over from Bellini as official painter of the Venetian republic but also serving successive Holy Roman Emperors and a series of monarchs, becoming the most famous artist in Europe. During his career, which included a stay in Rome in 1545–6, he tested his abilities against the masters of central Italy,

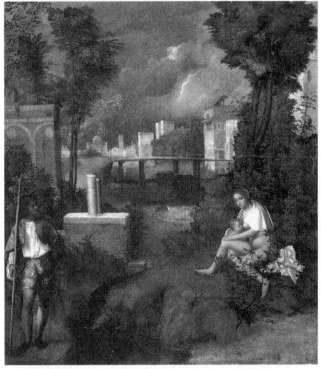

Giorgione, *La Tempesta*, *c.* 1506

above all Michelangelo, while developing Venetian col-
ourism to its highest level. His *Martyrdom of St Lawrence*,
painted in the late 1550s for the Jesuit church in Venice,
exhibits muscular Roman foreshortenings and monumental
classical architecture in steep perspective, consciously rival-
ling the best that his contemporaries could achieve. If this
heroic manner belongs to central Italy, the dramatic colour
belongs to Venice. The dark night is punctuated by bursts
of divine and man-made light, painted with livid streaks of

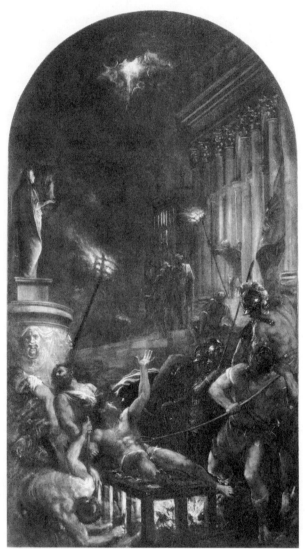

Titian, *Martyrdom of St Lawrence*, 1559

thick paint in which the flames are not so much described as physically emulated. The anguished saint looks and gestures to the high source of light that is cutting through the rumbling clouds.

Saint Lawrence, an early deacon of the Church, was condemned to death by the Roman emperor and was martyred by incineration. He therefore exemplified the often savage contest between pagan and Christian cultures. Titian, like other Renaissance artists, both relishes the grandeur of Roman culture and uses the glory of martyrdom to demonstrate the supplanting of ancient religions by Christ.

Just as Netherlandish techniques had been emulated and extended in Italy, so successive generations of Northern artists followed Dürer's route by adopting aspects of the Italian style, and, like the German artist, travelling to Italy. There was also the rarer option of absorbing what Italianate painters were doing in order to do something that differed from both the northern and southern traditions. The greatest master of this was Pieter Bruegel.

Bruegel's mature works in Antwerp, such as *Winter* (often called 'Hunters in the Snow') monumentalise peasant subjects in a way that conflates satire and sympathy. His series of 'Months' convey a vivid sense of the stoic country life as embedded in the remorseless cycles of the year.

Hunters, silhouetted dark against the stark snow, trudge over a wooded hill. Below, in panoramic array, a landscape unfolds, shaped by the ordering activities of irrigation and agriculture. Peasants are bringing bundles of faggots to a blazing fire outside the inn on the left. The skewed inn

sign depicts St Hubert witnessing his vision of the crucified Christ between the antlers of a stag. Below, distant skaters, curlers, golfers, and spinners of tops play on the frozen ponds. Black birds punctuate leaden skies.

This was a new way of looking at the earth and its inhabitants. One of Bruegel's close friends was the geographer, Abraham Ortelius, whose famous maps disseminated the Renaissance cartographers' new ways of envisaging the world. Ortelius was no simple map-maker. He was concerned with historical, economic and social geography. His sense of the habited body of the earth finds its perfect counterpart in Bruegel's panoramic visions.

Bruegel was as profoundly involved in acts of articulate seeing as Leonardo. He has captured how the glare of snow suppresses details of colour and surface modelling. The detail in the twiggy trees is systematically graded according

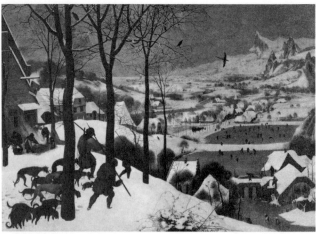

Bruegel, *Winter (Hunters in the Snow)*, 1565

to distance from the viewer's eye. Atmosphere progressively leeches out colour and veils the extreme distance. Silhouetted manikins lose the definition of their limbs as they move further away. Ortelius's 1573 epitaph for Bruegel imagines 'Nature's fear' that Bruegel's 'ingenious artifice in imitation would bring her into disrepute'.

Progressive mastery of nature marks this chapter, and such mastery could take as many forms as there were conceptions of nature. At one extreme was the extraction of mathematical rule and ideal beauty from the ragged diversity of nature; on the other was the assembly of minutely precise parts into radiant wholes. Those responsible came to see themselves as heroes of new kinds of visual enterprise.

1648
FRENCH ROYAL ACADEMY OF PAINTING AND SCULPTURE FOUNDED

4

ACADEMIES AND ALTERNATIVES

From the *Conférences de L'Académie Royale de Peinture et de Sculpture pendant l'année 1667* (translated in 1740) by André Felibien, prolific writer on art and artists:

Preface
Towards the End of the Year 1663, the King, by giving to Mr. Colbert the Office of the Superintendent of the Buildings, shewed he intended to make the Arts flourish more than they had done thereto. This Great Man [Colbert] … said there were two ways of teaching Arts and Sciences, by Precepts and by Examples: the one Instructed the Understanding, and the other the Imagination: And as in painting, the Imagination has the greatest Share of the Work, it is manifest that Examples are very necessary to make one perfect in that Art, and are the surest Guides to young Students … Although the Perfection of a Piece chiefly depends on the Force and Beauty of Genius, one cannot deny that any Analyses that might be made, would be of great Use.

(From the Conference of 5 November 1667 by Charles Le Brun on Nicolas Poussin's The Israelites Gathering Manna in the Desert):

Mr Le Brun ... *said he would divide his Discourse into four parts. In the first he would speak of Disposition in general, and of every Figure in particular. Secondly of Design, and the Proportions of Figures. Thirdly of the Expression of the Passions. And lastly material and aerial Perspective and the Harmony of the Colours ...*

The Painter having to represent the Jews *in a Country unprovided of every thing and in extreme Necessity, this Work must carry some Marks to express his Thoughts, and which may agree with his Subject. For this Reason, the Figures are in a languishing Condition, to express the Weariness and Hunger with which they were distressed. Even the Light of the Air appears pale and weak, which imprints a kind of Sadness on the Figures.*

The formation of academies of art, dedicated to the promotion of their members as socially prestigious, intellectually informed and imaginatively inspired, marked a change. Painters and sculptors had previously been members of guilds and were expected to serve long apprenticeships. Artists were employed on a contractual basis for each work, under strict conditions of size, materials, delivery and subject matter. During the course of the fifteenth and sixteenth centuries a series of elite 'super-artists' strove to claim a higher status alongside men of learning and literature. They could point to the disciplines needed for the imitation of nature, above all perspective and anatomy, and to the requirement that artists should be rich

in invention and rhetoric. Early academies of art aspired to provide education in the intellectual aspects of high art. This was the case with the first such foundation in 1563, the Accademia del Disegno in Florence under the aegis of Grand duke Cosimo de' Medici, acting at the suggestion of Vasari. The Accademia di San Luca followed in Rome in 1577.

The most powerful academy, the French Royal Academy of Painting and Sculpture, was founded in 1648. The institutional machinery of the French Academy was shaped into one of the tools used by the King's Finance Minister, Jean-Baptiste Colbert, to regulate economic and intellectual life. Under Colbert's regime, Charles le Brun, rhetorical painter of large narrative canvases, rose to a position of unrivalled power, ensuring that art promoted the official values of French culture.

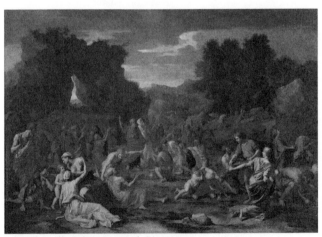

Poussin, *The Israelites Gathering Manna in the Desert*, 1637–9

One of the activities of the French Academy was to promote a series of 'Conferences', each dedicated to a canonical work of approved art, and led by one of the academicians. They were published by Felibien. The first contemporary painting singled out by Le Brun, Nicolas Poussin's *The Israelites Gathering Manna in the Desert*, may serve to define the norms to which all academies aspired.

Poussin moved to Rome in 1624 and his return to Paris in 1640 was not to be permanent. The painting's commissioner was Paul Fréart de Chantelou, one of a new breed of aristocratic connoisseurs. Given the painting's complex

THIS PAINTING DEFINES THE VALUES TO WHICH THE ACADEMY ASPIRES

CHARLES LE BRUN
PRESIDENT OF FRENCH ACADEMY
AND PAINTER

account of the starving Israelites' reactions to the fall of bread from heaven, Poussin wrote to encourage his patron to 'study the story and the picture to see whether each thing is appropriate'. In other words, the spectator should carefully examine how the artist produces a series of emotional set pieces to capture the essence of the Old Testament story.

Le Brun follows Poussin's procedure in his account of the composition. He quickly begins to read the poignant episodes: 'there is a woman giving the Breast to another old Woman, who seems to fondle a young child … There is an old man, whose Back is naked … A young Man is holding him by the Arm, and helping him to raise up … A Woman turning her Back, and holding a Child in her Arms … is beckoning to a young Man, who has a Basket full of Manna in his Hand, to carry some of it to the old Man'. Le Brun explains how each group is a tableau within the tableau. He is eager to point out (not always convincingly) how Poussin's poses depend on a deep study of works from ancient Rome. He explains how to read the expression of each of the actors' inner emotions. Everyone behaves with decorum; each person acts perfectly in keeping with his or her gender, age and social position. The praying Moses and pointing Aaron gravely emphasise the heavenly origins of the miracle, while two boys scramble competitively on the ground for manna. Every aspect of the setting – landscape, sky, light and colour – contributes to the whole. Le Brun also explains that Poussin is not showing a single moment but is telling the story as a great dramatist would. This is poetry, rhetoric, history, theatre, opera, and visual music where everything is deliberated to an extreme degree.

Alongside the art produced in the academies – some great, some worthy, much dull – arose a series of vigorous alternatives from artists who aspired to portray nature in a manner more direct and less rhetorical and idealised than that of academic artists. But, as always, nature and its imitation meant different things to different artists in different contexts.

The most powerful alternative in large-scale figure painting was the style of Caravaggio. Arriving in Rome, then dominated by the Roman Academy, the assertive young Lombard with a gift for vivid still-life painting, showed a marked inclination to ignore traditional disciplines like perspective. He was taken up by a group of adventurous patrons and young artists. Dealing with the turbulent Caravaggio was rarely without problems, and he has come to serve as an exemplar of wilful rebellion and creative fervour.

His *Crucifixion of St Peter* in the Cerasi Chapel in Santa Maria del Popolo demonstrates the extreme directness and relentless focus of his narrative style. The compact chapel had been acquired in 1600 by Tiberio Cerasi, the papal treasurer, and he commissioned Caravaggio and Annibale Carracci to provide the painted decorations. Carracci, from the Bolognese family of artists, was to paint the *Assumption of the Virgin* for the altar in a colourful early Baroque style, animated by elaborate motions and gestures. Caravaggio was to supply lateral narratives of the two highest-ranking saints, Peter and Paul. On the right wall of the chapel, we now see Paul collapsing backwards into our space with a diagonal thump, blinded by the light of revelation. On the

left, the cross of St Peter, to which he is already nailed, is laboriously levered into its inverted position. In a claustrophobic and starkly illuminated space, harsh realities assert themselves in a highly selective manner: sinewy and wrinkled skin, coarse garments, creased brows, grained

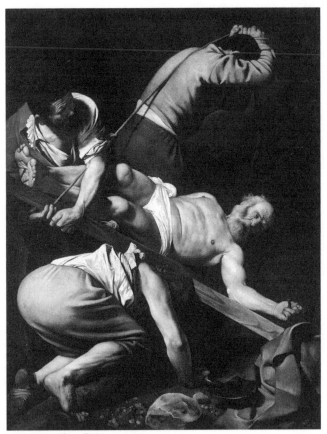

Caravaggio, *Crucifixion of St Peter*, 1600–1601

wood, iron nails and the taut rope biting into the jerkin of the uppermost labourer. The exaggerated physicality is designed to emphasise the saint's sacrifice.

The intensity of expression is very much in keeping with the reassertion of Christian intensity in Roman Catholic religious art, a vigorous response to the iconoclastic tendencies of Northern Europe's Reformation. The most assertive realisation of Papal Rome is the sculpture and architecture of Gian Lorenzo Bernini. The spiritual dynamism of Bernini's forms in space is exemplified by his *Ecstasy of St Theresa*, finished in 1652 for the Cornaro Chapel in Santa Maria della Vittoria. The sculptural centrepiece of the chapel is illuminated by a concealed light that gleams on the gilded rays; the ecstatic virgin saint, collapsed in a cascade of folds, is stabbed repeatedly by a joyous angel. As Theresa herself recalled, the angel wielded 'a long spear of gold':

> The angel appeared to me to be thrusting it at times into my heart, and to pierce my very entrails; when he drew it out, he seemed to draw them out also, and to leave me all on fire with a great love of God. The pain was so great, that it made me moan; and yet so surpassing was the sweetness of this excessive pain, that I could not wish to be rid of it.

Bernini has captured the deepest moment of the saint's spiritual intercourse. God transforms the supreme discomfort of her flesh into the divine delight of her soul.

On either side of the chapel, sculpted men from the Cornaro family are visible behind balconies at the end of

vaulted arcades. It is sometimes said that they are literally watching, like spectators in a theatre. They are not. They are considering the mysteries of the event, and of the ritual of the regular masses performed by the priest in our earthly realm. Theresa's is an inner vision, and so is theirs.

Bernini's art is the epitome of what we mean by 'Baroque': dominated by complex and contrasting motions, spatial fluidity, dynamic asymmetries, and powerful light

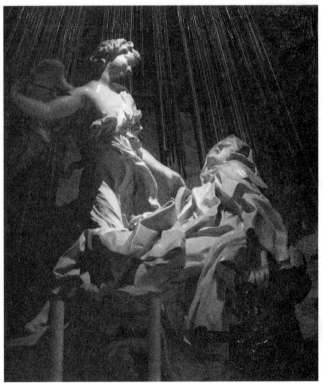

Bernini, *Ecstasy of St Theresa*, c.1647–52

and colour. However, in case we should be tempted to polarise the 'classical' Poussin and the 'Baroque' Bernini, it is worth noting that Poussin's champion, Paul Fréart de Chantelou, was a great admirer and companion of the sculptor. Bernini was no less passionate about antiquity than Poussin, though they brought different eyes to it. As we saw with the *Laocoön*, antiquity could look quite Baroque on its own account. The vigour and grandeur of Baroque art gives powerful expression to the grandiloquence of Church and state often acting in conjunction. It is an art of strong rhetoric and big gestures of power.

Peter Paul Rubens from Flanders is the painter we usually think of in this Baroque context. Greatly favoured by the crowned heads of Europe, he was the natural successor to Titian – and like his Venetian predecessor was knighted by a Holy Roman Emperor (Philip IV of Spain). Like Jan van Eyck, he served as an ambassador, active in some of the most important European disputes. From his base in Antwerp, he created major works for France, Italy, Spain and England (where he was also knighted by James I). Classically educated and aristocratic in manner, he was the grandest of grand painters, specialising in Catholic and secular histories on large scales.

His *Horrors of War* plunges us into the turbulent events of his international career. Commissioned in the late 1630s by Duke Ferdinando de' Medici of Florence, it alludes to the Thirty Years' War. The flaming composition surges in compressed disarray to the right, as if it were the liquidised frieze of an ancient sarcophagus. The god of war, Mars, with his blood-red cloak, is dragged onwards by the Fury

Alekto, accompanied by pestilence and famine. Venus – her pink flesh pressing on the gleaming steel of Mars's armour – ineffectually implores her lover to relent. On the left a distraught woman cries to the heavens, outside the doors of the Temple of Janus, rent open by war. Civilised values are literally trampled underfoot: Mars treads on a book and a drawing; harmony tumbles to the ground with a broken lute; a terrified woman with a baby and an architect have fallen under the onslaught. Brilliant opaque highlights, sensuously translucent glazes and flaming brushwork serve to animate every inch of the violent canvas, demonstrating Rubens's colouristic virtuosity in a self-conscious manner.

Rubens was exceptionally productive, both on his own account and via his large workshop. The greatest independent master to emerge from his workshop was Anthony van Dyck, who, moving to London in 1632, took up Rubens's links with the English Court where he was knighted and appointed 'principalle Paynter in ordinary to their Majesties',

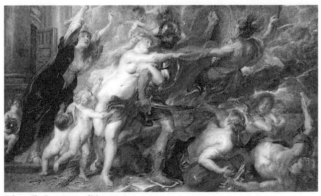

Rubens, *The Consequence of War*, 1637–8

Van Dyck, *King Charles I at the Hunt*, 1638

King Charles I and Queen Henrietta Maria. The king was as much a failure as a monarch as he was a success as the greatest collector of art in Britain from any period. Given the continued restrictions of subject matter for art in the wake of the Reformation, van Dyck's major activity was as a portraitist, but he transformed the genre in such a way that each of his major canvases became a kind of 'theatre' in its own right.

Van Dyck's *Charles at the Hunt* is highly inventive, at once regal and informal. The diminutive king stands with posed nonchalance, his silken elbow thrust towards us. His cane and sword speak of aristocratic command. The low horizon ensures that he looks down on us, however benignly. The deferential horse and the two grooms are literally cast in the shade. Equestrian portraits had become fashionable for rulers in both sculpture and painting, as had standing full-lengths. Van Dyck artfully combines the two in a composition that looks natural, even spontaneous, in its depiction of man at ease with the countryside he rules. However, it's unlikely that the king is wearing actual hunting gear, and such a wide-brimmed hat would not be suitable for fast galloping. The painting technique loses nothing in comparison to that of Rubens. The brushwork is attentive

yet fluid, while the translucent glazes and opaque passages of thick paint (impasto), with colouristically open shadows, conjure up effects of light and texture without apparent effort. The artistic poise of the painter and the magisterial poise of the monarch work together.

The painter has become a gentleman. When Sir Anthony died in 1641, to 'the universal grief of lovers of painting', his tomb declared that 'for all the riches he had acquired, Anthony van Dyck left little property, having spent everything on living magnificently, more like a prince than a painter'.

A comparable setting of courtly magnificence, albeit a characteristically Spanish one, is evident in Diego Velásquez's famed *Las Meninas*. Velásquez had risen to a point of high esteem in the Spanish court of Philip IV and had been granted the use of the large room in the Alcázar Palace that we see in the picture (overleaf). He was effectively the director of court art and curator of the royal collection, which included masterpieces by Titian and Rubens. Velásquez shows himself, brush and palette in hand, working on a huge canvas, somehow exercising a magnetic attraction in spite of his subsidiary position. His 'studio' is visited by the only child of the king and queen, the Infanta Margarita Teresa, with her entourage, including two maids of honour (the *meninas*) a dwarf and a leonine dog. They are looking out of the canvas at us, or, by implication, at Philip and Mariana who are (again by implication) either arriving or about to leave, perhaps through the doorway at the far end of the room, where the vanishing point of the perspective is located. They will not have been standing long

for the grand double portrait that is reflected luminously in the mirror. Rulers did not 'sit' for long hours as later artists required.

The set-up seems at first to be straightforward, but the painter has not mapped out the space in an explicitly geometrical manner. There are enough missing and inconsistent clues to prevent certainty. We are invited to explore visual and psychological possibilities – a temptation that legions of art historians have not resisted. We are teased into alternative readings of the interacting permutations of the artist, the unseen king and queen, the unseen face of the canvas, the infanta's entourage, the man in the door and ourselves. Velásquez, the infanta and the dwarf compete to meet our eyes with assured glances. The light and shade play elusive roles in the visual games. Just-identifiable canvases by Rubens and others hang darkly on the walls, outshone by the mirror, which seems to reflect the painter's own canvas. The brightest patch of light paint, on the distant wall through the door, paradoxically moves backwards not forwards. The paint itself promises definition but offers only seductive suggestion. Impulsive slashes and wriggles of impasto melt into the sheen of finely tailored silk or the rough coat of the dog. The magic is equal to but distinct from that of Titian and Rubens.

Three years after the painting was completed, and a year before his death, Velásquez was admitted to the ancient Order of Santiago. The red cross of the order was imposed on his chest. The existence of the legend that the king himself painted the cross tells us a great deal about the perceived status of the greatest artists in the mid-seventeenth century.

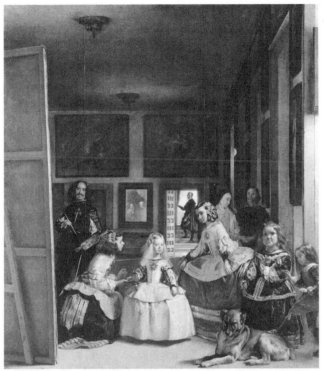

Velásquez, *Las Meninas* (*The Maids of Honour*), 1656

In 1648, Philip IV eventually recognised the independence of the Seven United Provinces of the Protestant Netherlands. As in Britain, portraiture reigned supreme, though other genres flourished: landscape, townscape, interiors, still-life and animal painting. The prospering Dutch were the first to leave a substantial and varied record of their bourgeois mercantile society and the agricultural ambience of farmers and peasants. In the middle of the century Paulus Potter was to paint the portrait

of a bull in a canvas over 11 feet wide! This is not to say that classicising painting was absent, and Rembrandt certainly harboured aspirations to rival Rubens in Catholic Antwerp. He did so in a direct style that was less susceptible to grand idealisation. He was no less adept than Rubens and van Dyck at cajoling freely applied paint to perform suggestive miracles of description, but without the conscious grace his rivals acquired from Venetian art.

Like van Dyck, Rembrandt van Rijn transformed portrait painting into a genre that could convey deep significance and what Leonardo called 'the motions of the mind'. He was the first artist to explore the outer and inner processes of his own life through a sustained series of painted self-portraits. The picture we are looking at here, from the peak

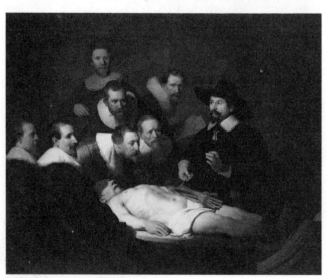

Rembrandt, *Anatomy Lesson of Dr Tulp*, 1632

of his worldly success, makes a great deal from a potentially tedious subject. His brief in 1632 was to paint a group portrait of the Amsterdam Guild of Surgeons. Earlier painters had grappled unhappily with the collection of bearded surgeons in dark suits. In his *Anatomy Lesson of Dr Nicolaes Tulp*, Rembrandt directs a mini-drama, setting the corpse of the dissected criminal at an angle and surrounding its torso with a conversational assembly of reactive individuals, whose expressions range from surprised awe to complacent awareness.

In fact, the narrative is contrived. The standard order of dissection (determined by rate of putrefaction) was abdomen, brain or thorax and finally the limbs. Tulp is anomalously shown beginning with the muscles and tendons that operate the hand. He is demonstrating the flexor tendons, and we can clearly see in the fingers how the superior tendon bifurcates to anchor in the inferior tendon, a mechanism regarded as one of the wonders of God's engineering. Tulp is using his own left hand to demonstrate how this mechanism achieves the delicate gripping action of the opposed thumb and forefinger. As a pioneer of the study of primates, Tulp was demonstrating how our hand, known as 'the instrument of instruments', defines our uniquely human gifts. Rembrandt is of course at the same time overtly displaying his 'artist's hand'. The shadows, in the tradition of Caravaggio, are more penumbral than in Rubens, while pools of light are more selectively abrupt. Rubens endows violence with stylishness and grace, while Rembrandt colours the learned research of middle-aged men with the polar emotions of tranquillity and turmoil.

The Dutch effectively invented genre painting as a major branch of the pictorial arts, and in the hands of Johannes Vermeer it became a vehicle for the refined contemplation of optical magic and social decency. In his bourgeois interiors, suffused with pale light, he meticulously locates well-attired ladies, gentlemen, their servants and their furniture on chequerboard floors. They act like decorous chess pieces in quiet games of music-making, letter reading, restrained courtship and domestic duty. What looks like detailed description is a trick in which we are perceptually implicit. Generalised planes of colour, interspersed with little pearls, worms and puddles of reflected light, persuade us to see more than is there. The synthesis of light, colour and space almost certainly indicates Vermeer's use of optical devices like the camera obscura – the 'dark chamber' with a small aperture that forms an image on a light screen.

We may feel the camera's effect even where it is not used directly, as in his *Art of Painting* from the mid-1660s. It may be that the heavy curtain signals the way he darkened the end of a room to transform it into life-size camera obscura. The painter with brush and mahl stick has just begun to portray Clio, the muse of history, with her book and the trumpet that heralds fame. The cast of a large sculpted face lies discarded on the table as if to say that anything sculpture can do painting does better. The magnificent map behind Clio, strafed into relief by the raking light, is Claes Janszoon's Visscher's cartographic description of the less than wholly united Provinces, flanked by pictorial vignettes of the main cities. The painting is deeply about acts of seeing and representation, and a vivid demonstration of the

gentlemanly art of painting. Vermeer retained the painting until his death and it clearly meant much to him. However, there is no case for thinking that he actually worked in such finery and without the necessary clutter of painting materials. It is a living miracle of the *art* of painting, not a realistic description of the *act* of painting.

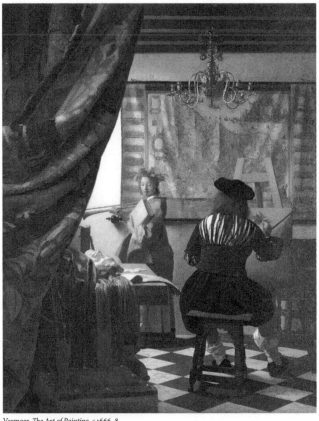

Vermeer, *The Art of Painting*, c.1666–8

The Dutch also redefined other ways of painting nature. Accomplished landscape, animal and seascape painters ennobled the everyday, the rural and the marine. Jacob van Ruisdael's *Windmill at Wijk bij Duurstede* is an example of how land, sea and sky can evoke the daily drama of existence as profoundly as any religious narrative. The windmill, translator of insistent Dutch winds into economic power, stands proudly near the bank of the broad inland waterway, towering over the more distant Castle of Wijk. Clouds scud overhead. Two trade vessels wait on the flat waters. Three women walk a curved path to the small town behind the ridge. The Netherlands was built on water-born power, and engaged in a constant battle to protect and reclaim the 'Low Countries' from the encroaching seas. It is a moist

Ruisdael, *Windmill at Wijk bij Duurstede, c.1670*

territory of big skies stretching to flat horizons, with orderly agriculture and neat brick townships. The particular speaks of the general: Ruisdael looks at a windmill to tell the story of somewhere that was and is unique.

Art became polarised in form and function. The diverse regimes of powerful states, ranging from the totalitarian monarchies of Catholic Spain and France to the complex bourgeois societies of Protestant Britain and the Netherlands, fostered types and scales of art that satisfied very different kinds of needs. A Ruisdael hanging in the town house of an Amsterdam merchant did a very different job from Bernini's St Theresa. What is generally shared across this wide spectrum is a growing social and intellectual ambition to make visual art something special in the annals of human culture.

5

CONNOISSEURSHIP AND CRITICISM

From *A Discourse on the Dignity, Certainty, Pleasure and Advantage of the Science of the Connoisseur*, 1719, by Jonathan Richardson, painter and collector:

There are Few that pretend to be Connoisseurs, *and of those Few the number of Such as Deserve to be so call'd is very Small: 'Tis not enough to be an Ingenious Man in General, nor to have seen all the Finest things in Europe, nor even to be able to Make a good Picture, Much less the having the Names, and something of the History of the Masters: All This will not make a man a good* Connoisseur, *To be able to judge of the Goodness of a Picture, most of those Qualifications are necessary, which the Painter himself ought to be possessed of ...; He must be Master of the Subject, and if it be Improveable he must know it is so ... He must be acquainted with the Passions, their Nature, and how they appear on all Occasions. He must have a Delicacy of Eye to judge of Harmony, and Proportion, of Beauty of Colours, and Accuracy of Hand; and Lastly he must be conversant with the Better Sort of People, and with the Antique, or he will not be a good Judge of Grace, and Greatness. To be a good* Connoisseur *... a Man must be as free from all kinds of Prejudice as possible; He must moreover have a Clear, and Exact way of Thinking, and Reasoning; he must know how to take in, and manage just Ideas; and Throughout he must have not only a Solid, but an Unbias'd Judgment. These*

are the Qualifications of a Connoisseur; *And are not These,
and the Exercise of Them, well becoming a Gentleman?*

For artists to convince themselves of their intellectual merit, elevated purpose and high social status was one thing; to convince a broader swathe of educated society was another. This is where the connoisseur comes in – and eventually the art critic. A characteristic development of the eighteenth century was the rise of the expert who by dint of sensibility, practice and knowledge could bring an accomplished eye to bear on questions of visual quality. The connoisseur could tell the superb from the very good, the original from a copy. The last of these was a powerful motivating factor for Jonathan Richardson, in the face of the large volumes of imported paintings claiming to be by one great master or another. Who could guide the eager collector of 'old masters' – as when 'a Drawing, or Picture be offered to him as being of the Hand of the Divine Rafaelle?':

> If this Judicious *Connoisseur* sees in it no Fine Thought,
> no Just, nor Strong Expression, no Truth of Drawing, no
> Good Composition, Colouring, or Handling; in short
> neither Grace, nor Greatness; but that on the contrary 'tis
> Evidently the Work of some Bungler, the Confident Pretences
> concerning it impose not on Him; He knows it Is not, it
> Cannot possibly be of *Rafaelle.*'

Richardson was a skilled painter as well as a collector, but the connoisseur could be an *amateur*; someone not professionally involved in producing art but who had cultivated refined skills in judgement. Being an *amateur* came to have a special social cachet. The pioneer Parisian dealer,

Edme-François Gersaint, claimed that the knowledgeable art lover could aspire in sensibility to become 'the equal of those superior in rank and condition'. The discernment of quality was all: 'a genuine *amateur*, or I should say, a true connoisseur, is less concerned with a painter's name and the rarity of his paintings than with the quality of his work'.

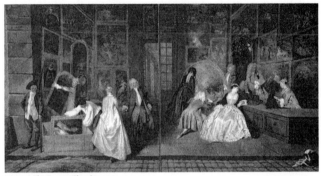

Watteau, *The Gersaint Shop Sign*, 1721

Gersaint was a new kind of art man. From his premises on the Pont de Notre-Dame, he sold paintings and curious artefacts. He staged public auctions, issuing catalogues with informative essays and frontispieces designed by leading artists. It is in a catalogue from 1734 that Gersaint tells us the origin of his famous *Shop-Sign* by Jean-Antoine Watteau, a masterpiece capturing transactions between the new connoisseur-collectors and enterprising merchants meeting their demands.

Gersaint tells how the ailing painter, who was in terminal decline with tuberculosis, offered to paint an 'overdoor' for the dealer's rebuilt premises in 1720. Gersaint argued that a shop sign was not the most prestigious form of art

– Watteau was a member of the Royal Academy – but the painter insisted that he wanted to 'flex his fingers' after a period of enforced inactivity. Watteau's touch is fluttering and feathery, his 'hand' as delicately eloquent as those of the ladies who perform in his little theatre of art.

An elegantly contrived tableau, composed from subsidiary tableaus in the Poussin manner, is now devoted to an urban version of Watteau's *fête galantes*, the genre of picture that had brought him fame. Whereas his *fêtes* were typically staged in softly melancholic country settings, the customers in Gersaint's shop enter a world of densely hung paintings that portray figures, many naked, in fecund nature. The front wall of the shop is dissolved, as on a stage. An impossibly slender young woman in pink silk is conducted through the invisible portal by her attentive beau. She looks at a portrait of Louis XIV by Mignard being crated – perhaps an oblique reference to Gersaint's old shop sign. A bale of straw for safe packing is ready, as is the coarsely dressed porter. Another man carries what appears to be a mirror. At the rear of the shop on the right a more senior woman applies her lorgnettes with studied attention to a large oval canvas, peering at the brushwork of the trees and sky, while her husband scrutinises a trio of lush female nudes – for the sake of art of course. It may be Gersaint who supports the ornate frame and gestures in a proprietorial manner. Mme Gersaint is probably recognisable on the far right, located in front of a picture of a suckling Madonna accompanied by saints in a Venetian-style landscape. She is proffering what appears to be a small mirror to two men and a seated *mademoiselle* who gracefully inclines to look. The

standing man, more interested in his own reflected image than the paintings, seems to be clasping a glittering garment to his person – perhaps a piece of imported exotica.

The tone is not so much mocking as affectionately wry, as Watteau looks at the world that provided him with sustenance, and which he probably sensed he was leaving. He was to live no more than a year, expiring in the arms of Gersaint at the age of 37 (the same age as Raphael). As with Giorgione and Mozart, dying young is a good career move in the posthumous cultivation of a romantic persona.

As the rising bourgeois acted upwards, emulating the manners of their 'betters', so aristocrats (as they always had) acted up on their own account, striking poses in what was an increasingly international society of arts. Young northern aristocrats went to the artistic south to visit great collections. The British went to Paris and everyone went to Italy. Some of those who could afford it, and some who barely could, caught the collecting bug. Venice, Florence and Rome were particular high points. Alongside the old masters, a market developed in *vedute*, views of the urban spaces in which admired buildings sat. The most brilliant of the *veduta* painters was Antonio Canal, known as Canaletto, and he was favoured by the British, whose appointed consul in Venice, Joseph Smith, was a major collector and acted as a kind of agent.

Looking at one of many views of the Piazza di San Marco by Canaletto (overleaf), we will not be astonished to find that he was the son of a painter of theatrical scenery. The latest fashion in north Italian stage design was the *scena all'angolo*, which used diagonal vistas. Beside the angled facade of the

Canaletto, *Square of S Marco, Venice, c.* 1742–4

great 'byzantine' basilica of San Marco, the Doge's Palace steps back diagonally in meticulous though gentle perspective, opposite a column carrying the lion of St Mark and towards the maritime *basino* with its gracious gondolas and ornate galleons. The 'Serene Republic' gleams. Costumed actors play their parts, interspersed with stallholders and just one token beggar in the portal. The smaller details are captured with little dots, squiggles and commas of paint in a miraculous shorthand as economical as Vermeer's but more self-consciously ornate. Now in Washington, the painting was originally a prized asset of Castle Howard in Yorkshire.

The artist who most pointedly pricked the balloon of pretence that often prevailed in these arty circles was, surprisingly, English. The surprise is not that William Hogarth's 'modern moral subjects' should emerge from English political and literary culture but that an English artist

should effectively invent a new genre when his immediate predecessors had not proved notably adept at the old ones – with the possible exception of portraiture. Satire was a major political tool and literary genre in eighteenth-century Britain. Jonathan Swift's *Gulliver's Travels* is a major literary example. Hogarth did not emerge from the established art world. He began as an engraver of politically angled prints before turning to painting.

While Hogarth developed into an accomplished painter of portraits and traditional narratives, it was his commentaries on modern manners that brought him fame. Two series narrate the short-lived rise and merited fall of a central character. We follow the *Harlot's Progress* in six scenes in 1731, and four years later we witness the *Rake's Progress* in eight pictures. Each painting was engraved and

Hogarth, *The Tête à Tête, Marriage à la Mode no. 2, c.1743*

the sets were sold lucratively on subscription. The third series in 1743–5 was *Marriage à-la-mode* (a Frenchified title) in which we watch the murderous disintegration of an arranged marriage between old aristocracy and new money.

In the second painting in the series, *Tête à Tête* (page 93), we peep at the morning after the wedding night, which has not, seemingly, resulted in the consummation of the marriage. The setting is a salon opening on to a picture gallery. The son of the bankrupt Earl Squanderfield slumps in debauched lassitude. A fluffy dog sniffs out the disgrace that the bridegroom has preferred to pass his wedding night with a woman of easy virtue, whose bonnet hangs from his pocket. His bride, to judge from her stretch and sneer, has found alternative satisfaction in the arms of a lover. The upturned chair and scattered items of frivolous entertainment tell their own story, while the despairing estate manager exits with a ledger of unpaid bills. As if this is not enough, the young man's neck is marked with the sign of the 'French pox' that he has acquired on previous expeditions.

Hogarth places his contemporary moral tracts alongside the great cycles of 'history paintings' revered in the academies. He was involved in the early teaching establishments in London, including the St Martin's Lane Academy, and produced his own treatise, *The Analysis of Beauty*, in 1753. In all this, he was little concerned to parrot the traditional dogmas, seeking something more direct and less inflated. As the key to beauty he looked not to a philosophically informed ideal but to a particular kind of serpentine line that experience of nature and art attests as

the essence of the beautiful. It should be added that Hogarth handles paint with a detailed panache to stand beside Watteau and Canaletto.

At this time the Academy in France was dominated by painting less monumentally serious than in the era of Le Brun. The taste, above all of the royal court, was set by a painter of modest origins who had engraved Watteau's compositions, François Boucher. He is the Rococo artist par excellence. The name Rococo (related to the English word 'rockery') was coined in the nineteenth century to refer to the sinuous and florid decoration characterising French design in the mid-eighteenth century. Curvaceous marine and plant forms provided important inspiration. Gersaint dealt in natural wonders, and Boucher's trade card for Gersaint's establishment, *A la Pagode*, parades a rich array of curious items, including a Chinese cabinet, exotic corals and ornamental shells.

Boucher emerged with a series of large mythological canvases in the early 1730s. The paintings do not seem to have been lucrative commissions but were intended to bring the young painter to the attention of connoisseurs, which they did to great success. The *Rape of Europa* (overleaf) shows Boucher's buoyant flair. He is recounting a story from Ovid's *Metamorphoses* of how the lustful Jupiter disguised himself as a bull: 'the muscles rounded out his neck, the dewlaps hung down in front, the horns were twisted, but one might argue they were made by hand, purer and brighter than pearl. His forehead was not fearful, his eyes were not formidable, and his expression was peaceful'. Thus fooled, the beautiful Europa and virginal companions gambol on

the shore with the benign beast. Jupiter's eagle in the upper right serves as a portent. Once seated on the animal's back, Europa is born helplessly to Crete, where she is raped. Boucher does not neglect the narrative, but the dancing composition, light-hued colours, luscious paint handling, and general air of frolicking joy are not designed to stimulate dark thoughts about Jupiter's rapacious intentions. Le Brun would not have approved of Boucher's appointment as 'First Painter to the King' in 1765.

Given the high seriousness inherent in French academic art, we might imagine that Boucher could look frivolous. Denis Diderot, prodigious philosopher, playwright, novelist, essayist and encyclopedist, and effectively the first art

Boucher, *The Rape of Europa*, c. 1732–4

critic, certainly thought so. From 1759 and 1779, Diderot wrote brilliantly conversational reviews of the Salons, the regular exhibitions staged by the Academy in the Louvre. His touchstones were nature and sincerity, and Boucher did not measure up in either respect. Diderot opens his attack on Boucher in 1765: 'I do not know what to say about this man. The degradation of taste, color, composition, has been followed little by little by the degradation of morals'. He recognised Boucher's charm, but this only served to make him more dangerous, because the painter 'has nothing of truth'.

Not the least important aspects of Diderot's entertaining squibs was that they did not respect the traditional hierarchy of the genres; the ranking of painting which placed 'history painting' at the summit of seriousness, with portraiture, 'low-life' painting, landscapes, animals and still life in a descending order. In fact, each genre was pursued with considerable verve in the Salons. One of Diderot's heroes was the quiet painter of domestic scenes and lowly still lifes, Jean-Baptiste-Siméon Chardin. He recognised that Chardin's subjects were not elevated. However, their supreme and honest naturalness transcended their social limits. What they could not do was summon up the full range of emotions Diderot demanded of the highest art.

Diderot opens the *Essay on Painting* that is appended to his Salon of 1765 with the declaration, 'Nature does not make anything inappropriately. Every form, beautiful or ugly, has its cause'. When he states that 'Chardin is true, so true' and that his work is 'nature itself', he is offering no small praise. Diderot could look towards Pliny for support in his admiration for eye-catching naturalism. The discoveries of

beguiling Roman still-life painting in Herculaneum and Pompeii also helped legitimise the genre.

The painting illustrated here is one of Chardin's contemplative genre paintings, undertaken before Diderot was writing his *Salons*. It draws upon the genteel bourgeois society into which the painter was integrated. Chardin depicts in close-up a young tutor instructing a girl. The painting is a miracle of eloquent and restrained precision. The tender yet prissy delicacy of the teacher's profile is translated into the steely gleam of the hatpin with which she points to the open book. The child's blunt face and stubby

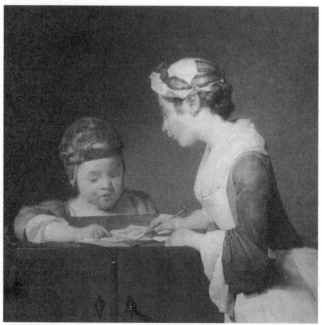

Chardin, *The Young Schoolmistress, c. 1735–6*

hand serve as counterpoints. Chardin exploits his unique kind of clotted surface, like unglazed ceramic, to create open surfaces that somehow become flesh and drapery. Nothing is overtly *described*, but, like Vermeer, he cajoles our perception into seeing materials that are not there. Diderot was alert to the suggestive magic: 'thick layers of colour are applied one upon another, and their effect seeps through from the first layer to the last … Go closer, and the picture blurs, flattens out, and disappears. Step back, and it is created anew, takes shape again'. He says the paint seems to be breathed on to the canvas.

In case we should think that Chardin, this son of a cabinetmaker, was a simple visual craftsman of scenes from his life, we should note that he was the manager and treasurer of the Salon, receiving substantial rewards from the king. His verbal reticence in the historical record, as with that of Velásquez and Vermeer, does not signal a lack of intellectual sophistication or social ambition.

Diderot was one of a radical group of French intellectuals determined to reform philosophy, society and culture in France. Britain was a source of inspiration, above all for its nature-based philosophy and experimental science. Newton was hugely admired, not least by Voltaire, the prolific author, philosopher, historian and social reformer, who was an early source of inspiration for Diderot. The most vivid images of Voltaire are by Jean-Antoine Houdon, one of the greatest portrait sculptors from any period. Among his sitters was Benjamin Franklin. Perhaps the most compelling of the 'speaking likenesses' he produced of Voltaire is the life-size seated statue in the Hermitage, commissioned by

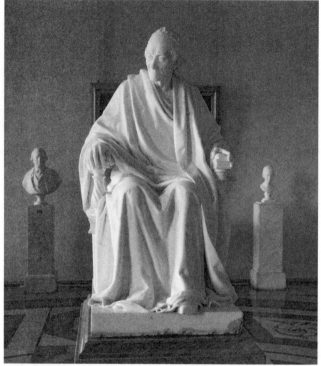

Houdon, *Voltaire*, 1781

Empress Catherine II in 1780. It was based on a terracotta sketch that was much admired in Houdon's studio, a sketch that was also used for a similar statue for the Comédie-Française in Paris.

Voltaire, aged and wiry, ensconced in an impressive chair, wears the gown of a venerable seer, which notably avoids becoming a Romanising toga. He turns his head to engage with an implied interlocutor. He smiles with quizzical shrewdness. The characterisation of his face

is naturalistic rather than conventionally antique. The normally blank or minimally described eyes of classical portraits have been replaced by excavated pupils with bright marble highlights. He sparkles with life. It is perhaps to be expected that Houdon was the author of brilliant portrait busts of Diderot, characterised with comparable living power.

Late in the day, Britain gained its official academy in 1768. The Royal Academy of Art was founded by George III, with Joshua Reynolds installed as its first president. High ambitions were reflected in the president's series of published *Discourses*, advocating the nobility of art through the emulation of the kind of history paintings of which Raphael remained the ultimate exponent. In spite

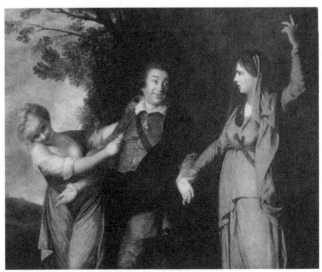

Reynolds, *Sir David Garrick between Comedy and Tragedy*, 1760–61

of the ideals, Reynolds's actual tastes remained lively and open in a way that was never submerged by academic dogmatism. In practice, Reynolds, like other leading academicians, depended on portraiture for the greater share of his patronage. Sometimes portraits could be blended with actual or implied narrative. This is shown in his 1761 portrait of the actor, David Garrick (page 101), torn between 'Comedy' and 'Tragedy'.

Reynolds's subject plays on the familiar ancient theme of Hercules at the cross-roads, in which the hero is confronted by two maidens, one of whom, plump and pink in a Boucherian manner, promises the seductive delights of a sweet and easy life, while the other, noble and austere, offers the bracing path of virtue. Hercules chose the latter. Garrick's choice is unclear. Pulled one way by a coquette, whose hair and costume are in anticipatory disorder, Garrick looks back with humorous remorse to the columnar woman pointing to higher things. The dagger at her belt belongs in a Greek or Shakespearean tragedy. 'But what can I do?' Garrick seems to be asking of her. In reality, Garrick was admired, by Diderot among others, for his ability to move from moods of joy to despair, from comedy to tragedy, transporting the audience across a full spectrum of emotions. He could have it both ways, even in the same play.

In 1789 the French monarchy was to move from Boucherian delight to Revolutionary tragedy, culminating in the execution of Louis XVI in 1793. The visual taste of the king's regime had been exemplified by Louis XV's mistress, Mme de Pompadour, who stood at the centre of a web of Rococo

extravagance. She was a major patron of Boucher. Significant moves against the Rococo were gaining impetus even before the Revolution. Lebrunian classical moralising was beginning to reassert its power in the Academy and at the Salon, in keeping with where things were going in France, as the monarchy came under increasing pressure for the kinds of reform that it could not accommodate.

The pre-Revolutionary transformation in the visual arts found its most unyielding expression in the paintings of Jacques-Louis David, who had studied in Rome for five years and who initially rose to prominence in royal circles. The painting that served to lay out his manifesto of reform at the Salon was his *Oath of the Horatii* in 1784. Gone is Boucher's ornamental froth. Three Roman brothers swear an oath to the fatherland as they salute the three swords

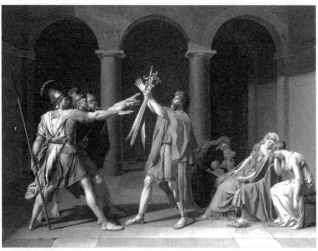

David, *Oath of the Horatii*, 1784

held aloft by their father. They are to do battle with three chosen sons from Alba Longa. The pyramidal severities of male resolve are contrasted with the tender delicacies of the women and children who represent the 'distaff side' – defined by the spindle and staff of softly wound wool on the hard floor. The setting is reduced to an austere perspectival box – a rudimentary realisation of Alberti's system – the tiled floor measuring the Horatii one behind the other, and finding them not wanting due proportion. The baseless Doric columns declare their historical virility as an affront to decorativeness. The Horatii have chosen a path at least as stony as that of Hercules.

Aligning himself with the forces of change, David became 'pageant-master of the revolution', not only immortalising its martyrs but also orchestrating bombastic state festivals and acting as arbiter of taste. Not even Le Brun enjoyed such power. As the Revolution metamorphosed into the Empire of Napoleon, David attached himself to the new regime with a mixture of agility, conviction and hero worship, creating a series of memorable set pieces in paint that have come to encapsulate the emperor's persona. No artist has ever played a more potent role in creating a vivid panorama of the extraordinary political landscape through which he journeyed.

The diversity of art in the seventeenth century, which effectively reflected national, local and social differences, had increasingly been replaced by diverse modes of art that could aspire to play active social roles within rapidly

changing societies. It is difficult to point to a dominant mode. Rococo elaboration and fun stood alongside the sober morality of Chardin and the keen satire of Hogarth. The range of people who could aspire to possess the various kinds of art was becoming far wider. The academies were still the places to make a reputation, not least with the rise of art journalism. It is on the walls of the French academy that we witness the supplanting of Watteau's courtly bourgeois by the harsh warriors of David's revolution. Along the way, the highly successful Boucher was overthrown, never to recover the reputation he had worked so hard to acquire. Sharply differentiated political messages were coming into play by the end of the century.

ROMANTIC LANDSCAPE

CONSTABLE

INGRES

FRIEDRICH

TURNER

CANOVA

DELACROIX

NEOCLASSICISM

ROMANTICISM

6
ROMANTICALLY REAL

Eugène Delacroix, *Journals*, On the soul of the painter:

October 1822
In painting a mysterious link is established between the souls of the protagonists and that of the spectator. He sees the features of external nature, but he thinks inwardly of the true thought that is common to all people, to which some give body in writing, yet altering its delicate essence. Hence, grosser spirits are more moved by writers than by musicians and painters.

May 1825
What makes torment for my soul is its loneliness. The more it expands among friends and the daily habits or pleasures, the more, it seems to me, it escapes and retires into its fortress. The poet who lives in solitude, but who produces much, is the one who enjoys those treasures we carry in our bosom, but which desert us when we give ourselves to others. When you yield yourself wholly to your soul, it opens itself completely to you, and it is then that this capricious thing permits you the greatest contentment … It is that of encountering all souls that can understand yours, and so it comes to pass that all souls find themselves in your painting.

January 1857
The main source of interest comes from the soul of the artist, and flows into the soul of the beholder in an irresistible manner. Not that every interesting work strikes all its beholders

with equal force simply because each of them is supposed to possess a soul. Only those people who are gifted with feeling and imagination are capable of being transported.

Napoleon's regime brought more precipitous convulsions to Europe than any earlier agency. Rome had invaded greater swathes of territory and the Reformation had convulsed the religious establishments of Church and king across Europe. The Spanish in the persons of the Holy Roman Emperors fomented imperial conflict in the sixteenth and seventeenth centuries. But the speed and orchestrated power with which Napoleon pursued his ambitions through modern warfare were unprecedented.

Spain represented the western extent of Napoleon's conquests. By dint of diplomatic subterfuge in 1807, some 23,000 French troops were admitted willingly into Spain.

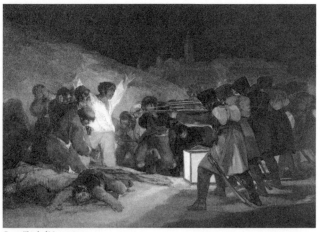

Goya, *Third of May 1808*, 1814

One factor in Napoleon's success is that he could be regarded as a modern-thinking liberator of peoples oppressed by ossified monarchies. This was a sentiment shared in part by the painter Francisco Goya, who had risen to a high position in the service of Charles IV at the same time as satirising obsolete values in Spanish society. The welcome for Napoleon evaporated in the face of events in May 1808. On 2 May a revolt against the French was followed by harsh repressions. A proclamation was issued: 'French blood has flowed. It demands vengeance. All those arrested in the uprising, arms in hand, will be shot'. The resulting butchery of Spanish citizens precipitated fighting over a five-year period in a guerrilla war (which is where our term comes from). When the French rulers were finally expelled in 1814, Goya offered to 'perpetuate by means of his brush the most notable and heroic actions of our glorious insurrection against the Tyrant of Europe'. He portrayed the urban fighting of 2 May and one incident from the shootings on the next day. Painters had portrayed contemporary events before, but no one had come close to the coruscating criticism that screams from the second of Goya's two canvases.

In a bleak slice of land outside Madrid, insurgents are marched from the city to a mound of pale earth already stained with blood. The glow of a square lantern illuminates the carnage. The soldiers, anonymous in their inhumanity, act as murderous automata. Their thrusting muskets with silver-sharp bayonets point to the breast of the next victim. He is a terrified peasant-martyr in white and gold, arms wide like St Andrew on his diagonal cross. A stigmatum on his right palm reinforces the holy allusion. A tattered and

tonsured monk prays with stiff intensity. Some stare with unbridled fear; others cannot look. The living are to join the layered pile of corpses. This is Madrid in 1808, but it could be other locations, past and present.

Goya had learnt from Velásquez – and from the Titians and Rubenses that he once saw daily – what paint could do in the service of both description and expression. Goya's brushwork is agitated by urgent passion, the outlines of the victims' bodies summary and broken. The sinister Caravaggio blacks and the glare of white innocence are stark.

Napoleon himself stands over 11 feet high, naked in smooth white marble, save for a fig leaf and rhetorical cloak over his left arm. Dancing on the orb in his right hand is a pretty statuette of victory in gilded bronze. The contrast with what was happening in Spain could not be more intense. That Napoleon could command a reluctant sculptor, Antonio Canova, to carve a monumental statue was an indication of the emperor's subjugation of Italy. Even the Pope was brought to heel – and to Paris. Canova, hailed as the foremost sculptor in the world, lamented what was happening to his native Venice and decried Napoleon's pillage of art works from Italy, including the *Laocoön*. But, like others, he had no choice, and was paid handsomely for his work. The monumental portrait, *Mars the Peacemaker*, was begun in 1802 and finished in 1806. It is an extraordinary work and an unhappy story.

The strange genre of portraiture that portrayed self-important sitters in the guise of ancient heroes and heroines was familiar in eighteenth-century France. Napoleon

Canova, *Napoleon as Mars the Peacemaker*, 1803-6

harboured reservations about appearing as other than himself. He was persuaded that nakedness and truth had traditionally gone hand in hand. The Director of the Musée Napoleon, Vivant Denon, suggested that the statue might replace the *Laocoön* in its Parisian niche. The huge marble, with its elaborate crate, did not arrive in Paris until 1810. Napoleon reacted adversely, and decreed that it should not be visible to the public. He may have been sensitive to elements of absurdity in the 'portrait', and the time for such heroic images was passing.

Canova for his part was making an enduring masterpiece of allegorical art for the master of Europe, not a short-lived likeness. Like other avant-garde artists in the Neoclassical camp, Canova's classicism was of a purified kind, seeking to reinstate the idealising phase in Greek sculpture rather than Roman muscularity. He could achieve effects of compositional grace and paradoxical surfaces of melting softness – a kind of soft porn in cold marble. The Napoleon is a superb application of Olympian idealisation to the monumental male nude – as far as its bodily form goes. The problem is that we find it difficult to get past the fact that its head is a kind of portrait, poised between the general and particular.

The denouement of the story is as strange as its earlier history. The Duke of Wellington, victor at Waterloo, persuaded the British government to purchase the marble giant after Napoleon's fall. It now stands, constrained for space, in the stairwell of Apsley House in London, the town house awarded to the Duke by a grateful nation.

The other incontrovertibly great master who emerged from the move towards a purified classicism was

Jean-Auguste-Dominique Ingres, a pupil of David, who stood as the standard-bearer of absolute values of the past, above all with respect to the primacy of drawing. But his actual standards at the Salon and elsewhere were anything but conventional. Although he was the champion of established values, the establishment was uneasy with his art. A symptom of his difficulties was a prolonged residence in Rome from 1806 to 1824 where he painted subjects and portraits that were not ringingly endorsed in Paris. One of his more extreme later paintings, the *Odalisque with Slave* of 1839 commissioned by his steadfast friend Charles Marcotte, gives a good sense of what he saw as orthodoxy, what critics saw as perversity, and what we see as individuality.

The resplendently exhibited and available body of the odalisque (a European fantasy of a Turkish chambermaid)

Ingres, *Odalisque with a Slave*, 1839-40

is moulded into implausible curves within a contrived silhouette. It is based upon a beautifully observant life drawing (Musée du Petit Palais), on which Ingres noted the name and address of the model. The setting is saturated in fashionable orientalism. Turkish decoration is observed with the same care with which he studied a Greek vase. Ingres' idiosyncratic draughtsmanship rules every inch of the canvas. The knees and legs of the slave who plays a long-necked Turkish *Oud* (the ancestor of the lute) are contained in an outline as succinct as a Giotto.

How can the exotic air of Ingres' odalisque be reconciled with his devotion to classical antiquity? A clue is given in the letters of Lady Mary Wortley Montague, the wife of the British ambassador to the Court of Turkey. In 1717 she visited a Turkish bath:

> The first sofas were cover'd with Cushions and rich Carpets, on which sat the Ladys, and on the 2nd their slaves behind 'em, but without any distinction of rank by their dress, all being in the state of nature … yet there was not the least wanton smile or immodest Gesture amongst 'em. They Walk'd and mov'd with the same majestic Grace which Milton describes of our General Mother. There were many amongst them as exactly proportion'd as ever any Goddess was drawn by the pencil of Guido [Reni] or Titian, and most of their skins shineingly white, only adorn'd by their Beautifull Hair divided into many tresses hanging on their shoulders, braided either with pearl or riband, perfectly representing the figures of the Graces.

The vision was one of erotic innocence, uncomplicated by Christian guilt at the 'Fall of Man' in the Garden of Eden.

Lady Mary's letters were published in 1763. There is a good deal of acrobatic special pleading here, but this kind of eye on exotic cultures presented Ingres with a way to see them as exhibiting the same timeless truths of linear draughtsmanship. It is, in general terms, a romantic vision.

Any discussion of the 'neoclassical' Ingres inevitably brings with it an account of Eugène Delacroix, his overtly 'romantic' rival. They certainly saw themselves as opponents, though with qualified generosity on Delacroix's part. In terms of subject matter they inhabited much the same territory and their tastes overlapped. They both loved Raphael and Mozart. They both participated in orientalism. Where they differed was in how the artist as stylistic performer aspired to communicate values, and what these values were. To Ingres' eternal linear verities, Delacroix opposed the colourists' fire as a means of communication between the soul of the artist and that of the spectator. Delacroix was prepared to journey into realms of melancholy, despair, fear and violence. Michelangelo's heroic struggles with the human condition became newly relevant, as we learn from Delacroix's brilliant *Journals*, published after his death. His writings are a diary of his inner life and artistic passions (across a wide spectrum, including music and theatre). They present the kind of deeply human confessional of pleasure and pain to which Ingres would never have admitted.

As a young artist Delacroix enjoyed more than one *succès de scandale*, with the emphasis on scandal in the case of his massive and turbulent *Death of Sardanapalus* (overleaf), exhibited at the Salon in 1827–8. It tells the story, already

the subject of a poem in blank verse by Lord Byron, of the Assyrian king whose subjects rioted against his rule. The text issued by the Salon explains that the rebels are poised to invade the palace:

> Lying on a superb bed, atop an immense pyre, Sardanapalus orders his eunuchs and palace officers to slit the throats of his women, his pages, and even his horses and favourite dogs; none of the objects that served his pleasure should survive him … Aisheh, a Bactrian woman, couldn't bear that a slave should kill her and hung herself from the columns supporting the vault … Baleah, Sardanapalus's cupbearer, finally set fire to the pyre and threw himself in.

Delacroix pulls no punches. Only Sardanapalus remains calm as oriental slaughter rages around his huge bed. Aisheh hangs from the top of the canvas, while threatening

Delacroix, *Death of Sardanapalusi*, 1827

smoke on the right tells us that the fire set by Baleah is taking hold. Nothing stabilises the transit of our eye across the canvas. The hot orange of cloths and metallic gold, the dusky flesh of the slave who stabs the terrified horse, and the pink bodies of the concubines pay extreme homage to Rubens's colourism. Key studies were undertaken in pastels to prepare directly for the conflagration of colour. Delacroix transports us via paint into the realm of the truly terrible.

No one could miss the challenge that the *Sardanapalus* posed to academic values. The painter and writer, Étienne-Jean Delécluze, who had studied with David, summarised the standard complaints.

> M. Delacroix's *Sardanapalus* found favour neither with the public nor with the artists. One tried in vain to get at the thoughts entertained by the painter in composing his work; the intelligence of the viewer could not penetrate the subject, the elements of which are isolated, where the eye cannot find its way within the confusion of lines and colours, where the first rules of art seem to have been deliberately violated. *Sardanapalus* is a mistake on the part of the painter.

At that stage it would have been difficult to forecast that Delacroix would become the official muralist of public buildings in Paris from the 1830s onwards. Ingres, while Delacroix was exploiting his painterly facility to create colourful narratives of Orpheus and Attila the Hun on the vaulted ceiling of the library in the Palais-Bourbon, was plotting the meticulous linear arabesques in his *Odalisque*. In person, the urbane sophistication and open intelligence of the mature Delacroix proved more amenable to the authorities than the crabby dogmatism and strangeness of

Ingres. However, they both had a great deal to say to the future.

Communion between the soul of the artist and the spectator lay at the heart of German Romanticism but with a far greater emphasis upon spiritual metaphysics. This is particularly true of its two greatest painters, Philipp Otto Runge and Caspar David Friedrich. The tone was set in the late eighteenth century by Wilhelm Wackenroder's *Effusions from the Heart of an Art-loving Monk*, compiled in 1797 by the poet Johann Ludwig Tieck. The spirit is profoundly pious and looks back consciously to the Middle Ages. Everything flows from and to God, and art serves as a mirror of divine omnipotence.

> Art may be called the flower of human feeling. It raises itself to the heavens from the most diverse regions of the earth in ever-changing forms ... In each work of art from every region of the earth, He perceives the traces of divine spark, which having issued from Him to penetrate the breasts of humankind, passes into their small creations.

How this vision could translate into an actual painting is shown in Runge's *Morning* in 1808, a small version of the large painting that he decreed should be cut into sections after his death. It was part of an ambitious project to create four major paintings of the 'Times of Day'. Runge completed a set of much admired prints, but of the paintings only *Dawn* was to be realised before his death at the age of 33. The radiant dawn of Aurora is heralded by Venus, the morning star. Vibrant life is infused into the slumbering earth. Joyous angelic babes, some winged and some un-winged, greet the

Runge, *Morning*, 1808

tiny entranced infant, who is presented with rosebuds. The central window, glowing like stained glass, is surrounded by genii and angels entwined with flowering amaryllis. The infants in the lower corners are still entrapped in cages of roots, and reach out to babies who foster an unwanted eclipse of the life-giving sun. The flavour of symbolic rapture is medieval, a return to Durandus in spirit, if not in actual imagery or style.

The colour is altogether remarkable. The golden radiance is complemented by the kind of violet-blue shadows that we associate with Impressionism. Runge was in fact an important theorist of colour, devising a 'colour sphere' through which he could achieve 'the construction of the relationship of all colour mixtures to each other'. Around the equator of his sphere are the primary colours of blue, yellow and red, interspersed with the mixed secondary colours, green, orange and purple. At the poles are white and black, with shades of grey in between. The sphere tells us that harmonies are produced by complementary pairs located opposite each other within the sphere, such as yellow and purple, as we see in the painting. This union of science and spiritual metaphysics permeates German thought in the Romantic era. Goethe, famed for his drama about Faust, published a book on the *Theory of Colours*. The aim was to forge a complete system of reason and revelation that would produce the ultimate art work. The result in Runge's *Dawn* may justly be described as symphonic.

Friedrich carried the metaphysical vision into the portrayal of landscape. Nature becomes not so much something to be portrayed by empirical inspection as

seen internally. Even his drawings directly from nature possess a hallucinatory quality. The paintings have such a searing intensity of tone and colour that one contemporary described them as making him feel as if his 'eyelids had been cut away'. Frequently, as happens in Chinese art, the scenery in Friedrich's paintings is witnessed by an observer within

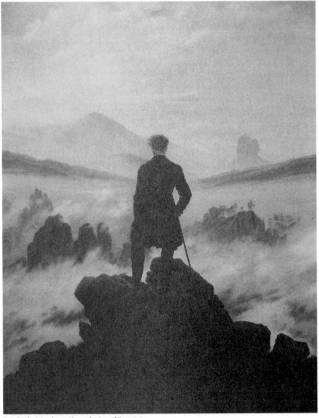

Friedrich, *Wanderer Above the Sea of Fog*, 1818

the painting itself. The silhouetted explorer in Friedrich's *Wanderer Above the Sea of Fog* (1818) has emerged from the enveloping mists into the pale glare of the heavens. The sharp tonal contrasts of the rocky foreground summit against the hazy indefiniteness of the flowing mists, and the extreme contrasts of scale between the man and distant trees, imply a space of vast extent. As Friedrich wrote, 'the eye and fantasy feel themselves more drawn to the hazy distance than something that lies near and distinct before us'.

German Romanticism drew heavily on the mystical tradition of Jakob Böhme, the seventeenth-century Protestant theologian. The first of Böhme's visionary writings was *The Rising of Dawn*. For Böhme, internal light manifests the divine: 'light glimmers in your whole body; and the whole body moves in the power and knowledge of the light, which signifies God the Son'. This is as relevant for Friedrich as it is for Runge.

We do not associate British art and thought with such high metaphysics, unless we look to William Blake. However, British Romantic literature and painting was strongly spiritual in tone in a general way. The dominant visions of painted nature were those of Joseph Mallord William Turner and John Constable, who stand alongside supreme landscape painters from any age. Like Delacroix and Ingres, they were declared rivals, and in a comparable way it was the more overtly emotional art of Turner that won most official approval. He was elected to the Royal Academy in 1802 and served as Professor of Perspective from 1807, a duty that he took very seriously, speaking on

Turner, *The Fighting Temeraire Tugged to her Last Berth to Be Broken Up*, 1838

colour as much as optical geometry. Constable had to wait until 1829 to become a full RA.

Like Friedrich, Turner was a painter of light, but his was external – a luminous medium in which he immersed himself to extraordinary effect. The range of his prodigious output was as wide as it could be: from moist local riverscapes to great classical vistas; from perspectival views of cities to thunderous seas; from sublime Alpine scenery to the shining Venetian lagoon; from carefully researched renderings of the Battle of Trafalgar to evanescent visions in which forms are dissolved by light. His most famous painting, *The Fighting Temeraire Tugged to her Last Berth to Be Broken Up*, cannot therefore be taken as fully representative but it shows his skills operating at full emotional power.

The subject is the funeral procession of the Temeraire, a ship of the line that had played a heroic role in the Battle of Trafalgar of 1805. For twenty years the ship had been moored in retirement. Dismasted and stripped of all fixtures, her hulk was dragged by two tugs from Sheerness to Rotherhithe to be salvaged as timber. Turner bends the facts: the painting is a narrative invention not a documentary. In the painting the pale ghost of the old wooden ship is towed by a dark metallic tug. The account published by the novelist William Thackeray captures the mood:

> The old *Téméraire* is dragged to her last home by a little, spiteful, diabolical steamer. A mighty red sun, amidst a host of flaring clouds, sinks to rest on one side of the picture, and illumines a river that seems interminable ... The little demon of a steamer is belching out a volume ... of foul, lurid, red-hot, malignant smoke, paddling furiously, and lashing up

Constable, *Landscape: Noon* ('*The Haywain*'), 1821

> the water round about it; while behind it (a cold grey moon looking down on it), slow, sad, and majestic, follows the brave old ship, with death, as it were, written on her.

Turner's picture is hugely poignant, but we should not assume that he always rejected the new age of metal and steam: he recognised the sadness of the passing of the old but relished the fiery excitement of the new.

The layout and execution of the painting stands outside old conventions of landscape painting. The asymmetrical composition of the primary forms is balanced by weight of colour. The great booming sunset is painted with thick smudges of paint, dark and light, that somehow hang in the air above the streaky blue distance. The black buoy, bobbing at an angle in the lower right, plays a vital role in forcing the sun and hot clouds into the distance. According to convention, dark forms retreat and bright forms advance in a picture. Turner violates the rules and somehow makes his alternatives work with a new vividness.

Constable by contrast seems very descriptive and Dutch. However, like Turner, his larger paintings are synthetic constructions. It is just that their artifice is subtly concealed under the surface. His large painting, *The Hay Wain*, no less iconic than the *Temeraire*, is full of pictorial contrivances to make it look natural. The location of the view at Flatford in Suffolk, featuring the cottage of Willy Lott, was known to Constable over a sustained period, since a mill owned by his father was nearby. He had undertaken smaller oil studies of the site, both independently and for the painting, before completing this latest 'six footer', as he called the big paintings submitted to the Academy. He had executed

a freely painted study at full scale in order to map out the tonal and colouristic effects. The only significant change in the final version is the elimination of a horse and figure to the left of the dog. It has been fashionable to prefer the full-scale study to the finished picture, but this is to misrepresent Constable.

The final painting goes beyond the broad layout in its detailed light effects, including the sparkling scatter of impastoed highlights that he jokingly called his 'snow'. The water shines moistly and breaks into glistening ripples as the wagon (the 'wain') and its two farmhands pass on their way. Scattered patches of sunlight chase across the distant meadow on either side of a strand of trees. The broken procession of clouds is utterly English – the 'sunny intervals with a risk of scattered showers' beloved of weather forecasters. Constable knew the latest meteorological researches into clouds, and had painted magical studies of cloud-laden skies – 'skying', in his own words.

It was this long-standing reservoir of systematic study that allowed him to produce what we see as a very specific record. The same applies to the individualised 'portraits' of trees, based upon long hours of understanding the contingencies of branching and the play of light on foliage. There is obvious inspiration from Ruisdael and the Dutch masters, but in retrospect they look stagey beside Constable's freshness. He was helped enormously by the wider range of available pigments. Indeed, his paintings received criticism for being 'too green' compared to mellow old masters. *The Hay Wain* caused a sensation of a favourable kind when it was exhibited at the Salon in Paris in 1824.

Whereas we look at the pictures of Constable's beloved Suffolk in terms of very specific locations, now tourist traps, *The Hay Wain* was exhibited as 'Landscape: Noon' – an 'effect', to induce feeling and mood, not a record of a named location. It is saturated in the love of small things: 'the sound of water escaping from Mill dams etc. Willows, Old rotten Planks, slimy posts & brickwork', as he confessed. These serve the greater whole of our empathy with the emotional texture of time and place. Turner works from top down – inserting details into mood – while Constable works from bottom up – synthesising mood from details. This is overly simple, but indicates the gravitational forces at work in their creative processes.

Finally, we cross for the first time to North America – for a special kind of natural sublime. By the mid-nineteenth century American landscape artists were beginning to speak with a distinctive voice, as they grappled with the grandeur of their vast wildernesses. This is true above all of Frederic Edwin Church. His *Niagara Falls, from the American Side* (page 127) in 1867 is as American as Constable is English. Based on a drawing Church made at Niagara Falls more than ten years earlier, it was composed with the aid of a photograph painted over with colour. At well over 8 feet high, the painting's expanse speaks of a vastness and majesty. From a viewpoint squeezed upwards towards the top of the canvas, we watch the plunge of waters as they throw up plumes of spray. Diminutive viewers on a perilous viewing platform on the left put our own scale into perspective. A fugitive rainbow spans the lower left corner.

Like Friedrich and Turner, Church knows how to set

absorbent dark against luminous brightness. The great tableau was commissioned by the New York dealer, Michael Knoedler, from whom it was purchased by John S. Kennedy, who presented it to his native Scotland, where it remains today.

Church, *Niagara Falls from the American Side*, 1867

What we have witnessed in our journey from Canova's *Napoleon* to the sublime landscapes is the increasing 'liberation' of art from the old diktats of patronage. This came at a price. Means of bringing works before the public – purchasers, critics and a broad spectrum of spectators – were necessary. Dealers and exhibitions played vital roles. Attention-grabbing subject matter needed to be generated. Eye-catching effects proved advantageous. Self-promotion and conscious individuality helped. Artists were literally selling their souls, whether romantically or classically inclined. The market for art, as for other cultural commodities, could be a tough place.

7

MODERN LIFE – THE FRENCH DIMENSION

From *The Painter of Modern Life*, 1863, by the poet and art critic Charles Baudelaire:

For the perfect flâneur *[a suave stroller through modern society], for the passionate observer, it is an immense joy to set up residence in the heart of the masses, in the flow and in the movement, in the fugitive and the infinite … Thus the lover of universal life enters into the crowd as into an immense reservoir of electrical energy …*

Thus the painter of modern life goes, he hastens, he searches. But searching for what? To be sure, this man … this solitary, endowed with an active imagination, always travelling across the great human desert, *has an aim loftier than that of a mere* flâneur, *an aim more general than a fugitive pleasure of circumstance. He is looking for that quality that you must allow me to call* modernity *… He strives on his own account to extract from fashion whatever it may contain of poetry in history, to draw the eternal out of the transitory … Actual painters, though choosing subjects of a general nature and applicable to all ages, nevertheless persist in dressing them up in the costumes of the Middle Ages, the Renaissance or the Orient … That transitory, fugitive element, whose metamorphoses are so frequent, you have no right to despise or to set aside. By neglecting it, you tumble violently into the abyss of an*

abstract and indeterminate beauty, like that of the first
woman before the Fall of Man.

The old artistic order was passing. The patronage of rulers and the Church was no longer central to the careers of artists. The academies were increasingly bypassed. Their exhibitions, so much a fact of life for Ingres, Delacroix, Turner and Constable, no longer automatically served as the prime arena in which avant-garde artists could parade their talents. The old subjects no longer seemed obviously relevant. What did it mean to be a modern artist in a modern age? This was Baudelaire's question and it was asked most insistently in France.

One answer was to set up an exhibition space and charge the public for entry. This is what the belligerent Realist Gustave Courbet did in 1855 when two of his paintings were rejected by the jury at the Paris Exposition Universelle. That eleven of his paintings were accepted was no matter. They had refused his huge painted manifesto, the ponderously entitled *The Painter's Studio. A Real Allegory of a Decisive Seven-Year Phase of my Artistic (and Moral) Life*. His reaction was to set up his own adjacent 'Pavilion of Realism' with a display of forty of his paintings.

In the statement issued to accompany his show, he rudely asserted his independence from the past.

> I have studied the art of the ancients and the art of the moderns, avoiding any preconceived system and without prejudice. I no more wanted to imitate the one than to copy the other; nor, furthermore, was it my intention to attain the trivial goal of 'art for art's sake'. No! I simply wanted to

draw forth, from a complete acquaintance with tradition, the reasoned and independent consciousness of my own individuality … To be in a position to translate the customs, the ideas, the appearance of my time, according to my own estimation; to be not only a painter, but a man as well; in short, to create living art – this is my goal.

His painted declaration is almost 12 feet high and some 19 feet long. Again, Courbet explained:

It's the whole world coming to me to be painted. On the right, all the shareholders, by that I mean friends, fellow workers, art lovers. On the left is the other world of everyday life, the masses, wretchedness, poverty, wealth, the exploited and the exploiters, people who make a living from death.

At the centre is Courbet, displaying his prized 'Assyrian profile', seeming to merge into the large landscape he is painting, watched by two appreciative spectators, an innocent boy and a disrobed model. Courbet came from a

Courbet, *The Painter's Studio. A Real Allegory of a Decisive Seven-Year Phase of my Artistic (and Moral) Life*, 1855

prosperous country background, which provided the basis for his stance as a rumbustious provincial outsider.

Among the 'shareholders' gathered on the right we recognise Baudelaire behind a table, reading. Seated halfway back is the Realist author and critic Champfleury. At the rear is Courbet's committed patron, Alfred Bruyas, in profile, and in full-face the socialist-anarchist philosopher, Pierre-Joseph Proudhon. It may be that the well-dressed woman in the foreground with her subsidiary husband (described by Courbet as 'cultivated *amateurs*') is George Sand who, with Champfleury, played a pioneering role in literary realism.

Identifying the actors in the denser 'everyday' group on the left is more testing. Below an apparently neglected sculptural model, perhaps a St Sebastian or St Bartholomew, we see a destitute Irish beggar suckling her baby. We can recognise other 'types' – including an undertaker, a merchant, a labourer, a priest, a rabbi holding a casket and a hunter with his dogs. It seems likely that some of the types also serve as covert and unflattering portraits of individuals in the estates of the emperor, Napoleon III, recognisable as the crestfallen hunter. Courbet's was a political art, anti-establishment and left wing, and he was an active political animal. His involvement in the destruction of the Vendôme Column and its statue of Napoleon I in 1871 during the brief Paris Commune was to result in his imprisonment and eventual banishment.

The painting itself is remarkable: tough and uncompromising in its vigorously bold execution, which is virtuosic yet not ingratiating; unseductive in colour; and devoid of

the harmonious principles of academic composition. The rhetoric of Realism is to assert 'this is how it is', speaking in a direct, contemporary manner, without pleasing displays of conventional graciousness. Realism is a stance, rather than a straightforward imitation of nature. An 'allegory' involves the contrived bringing together of meaningful components to convey a message. Courbet's 'allegory' is 'real' in as much as its unprettified components are drawn from the life that Courbet lived in the country and in Paris.

Alongside the triumphant official 'retrospectives' of Ingres and Delacroix, Courbet's one-man stand was not a great success. However, Delacroix himself was won over: 'I went to the Courbet exhibition. He had reduced the price of admission to ten *sous*. I stayed there alone for nearly an

Manet, *Le Bain (Le Dejeuner sur l'herbe)*, 1866

hour and discovered a masterpiece in the picture that they rejected'. Like us, Delacroix could not tell whether the rear wall of the studio showed a real landscape or a painted one.

Eight years later, the young lions of the avant-garde and their supporters, for whom Courbet was a shining example, found their works rejected by the Salon jury. The conservative Napoleon III was prevailed upon to establish a Salon des Refusées as a way of letting the public see what kind of works had been refused. The most provocative of the paintings in the alternative show of 1863 was *Le Bain* (page 135) by Edouard Manet, subsequently known as *Le Dejeuner sur l'herbe* (Luncheon on the Grass). Most spectators could not see past the licentious spectacle of two fully clothed 'modern' men lounging on the grass with one totally naked companion and one scantily clad. The negligent tumble of garments, overturned basket, fruit and bread did nothing to calm the spectators' anxieties.

Even Emile Zola, the great author and polemicist, who was portrayed by Manet in 1868, found the picture puzzling.

> ART WHICH HAS BEEN REFUSED SHOULD BE DISPLAYED IN ANOTHER PART OF THE PALACE OF INDUSTRY
>
> NAPOLEON III
> FRENCH EMPEROR

He resorted to an explanation that drained out the content: 'assuredly, the nude woman in *Le Dejeuner sur l'herbe* is only there to furnish the artist the occasion to paint a bit of flesh'. However, earlier in his account he came closer to what seems to be the best explanation: 'in the Louvre there are more than fifty paintings in which are found mixes of persons clothed and nude, but no one goes to the Louvre to be scandalised'. The most obvious example is the *Fête Champêtre*, variously attributed to Giorgione or Titian, in which two young men dressed in contemporary clothes are accompanied by two sensually naked women. More directly, the poses of the three foreground figures in Manet's painting are based upon two river gods and a water nymph reclining naked on a river bank in an engraving of the *Judgment of Paris* by Raphael. Manet has even taken over in the way that Raphael's nymph stares unabashedly at us. We can begin to make sense of what he is doing. He is, in Baudelaire's words, choosing a subject 'of a general nature and applicable to all ages', and refraining from dressing it up 'in the costumes of the Middle Ages, the Renaissance or the Orient'. As a 'painter of modern life', he is translating an old master convention into the present. It is self-consciously a painting about paintings and painting today. Manet was well aware of what his modernising gesture would bring.

Technique was integral to the updating. Rather than the smooth modelling and mellow tone of an old master, Manet allows the pale flesh of the naked woman to glare flatly as if spot-lit, while the dark coats of the men are flat and black. The paint is handled with abrupt sketchiness. The woman with her wet chemise in the river is, in conventional terms,

no more than an *ébauche* (a rough sketching-in), and the landscape is sketched with improvisatory speed. In short, the painting appeared unfinished. But this is part of it being 'of the moment', fresh and direct.

The feeling that a modern picture should present the spectator with engaging and apparently spontaneous sensations was taken further by Claude Monet in 1872 in a painting of sunrise in the harbour of Le Havre. By accident it became seminal and gave its name to a 'movement'. Due to be displayed in an independent exhibition staged by the Anonymous Co-operative Society of Artists, Monet's painting needed a title. He explained that 'it couldn't really be taken for a view of Le Havre, and I said, "put *Impression*"'. A conservative painter's mocking reaction was printed in the satirical magazine, *Le Charivari*: 'Impression – I was certain of it. I was just telling myself that, since I was impressed, there had to be some impression in it ... Wallpaper in its embryonic state is more finished than that seascape!' Other scathing critics seized on the title 'impression' to condemn the painting of such apparently transitory, insubstantial and subjective effects. However, for the artists themselves the term seemed appropriate, and they adopted it to signal the immediacy they wished to convey to the viewer. Thus Impressionism and the Impressionists were christened.

The painting itself was sketchy even by Monet's standards. There is no linear definition of form or conventional modelling. Masts, cranes, chimneys and smoke are barely differentiated in terms of paint application. We reconstruct forms as best we can from the painter's pacy translation of his impression into overtly brushy paint. The round orange

sun pushes through the dense atmosphere, streaking the water and acquiring implicit temperature and luminosity from the cool hues that frame it and its reflection. Only Turner, late in his career, had been anything like as radical in painting with coloured light. So popular are Impressionists' impressions today that it is difficult to gain a sense of how insulting such pictures seemed to traditionalists.

The show in 1874, known retrospectively as the First Impressionist Exhibition, included thirty independently minded painters. Thereafter annual shows were staged, and we find many familiar names – Cassatt, Cézanne, Degas, Monet, Morisot, Pissarro, Renoir, Sisley, for example. Gauguin participated in 1880. The Impressionists comprised a loosely affiliated association of modern painters, embracing a variety of styles. Edgar Degas was the

Monet, *Impression, soleil levant*, 1872

dominant figure in the 1881 exhibition, which advocated a permissive agenda of how to paint modern life. His own art was certainly not impressionist in Monet's sense of painting with coloured light. As an admirer of Ingres, Degas relied upon draughtsmanship – but in a strikingly new way.

FIRST IMPRESSIONIST EXHIBITION

1874

His *Place de la Concorde: Vicomte Lepic and His Daughters* (overleaf), painted in 1875 and subsequently modified, is as challenging compositionally as Monet's *Impression* was challenging colouristically. The grandly named Vicomte Ludovic-Napoléon Lepic, pencil-slim and elegantly attired, strolls with the nonchalant air of a *flâneur* across a square. His two daughters, who may not originally have been part of the composition, disconcertingly face in the other direction, as does their dog. They are cut off abruptly above the knee, an effect enhanced when Degas wrapped about two and a half inches of the canvas around the stretcher at the bottom. An attenuated and lugubrious man at the left is truncated at top, bottom and rear. Between them is a yawning space. It may be that the arbitrary cropping refers to photography, but no one would boast of

PISSARRO

a photograph so 'badly' composed. The overall effect is poised somewhere between a narrative and a strangely conceived group portrait. It is certainly about modern life, but is as enigmatic as Manet's *Dejeuner*, with which its sketchy painting handling has obvious affinities. It somehow now looks 'right' to us, perhaps because Degas has trained us to see in a new way. The vicomte was from a distinguished military family but had trained as an artist. He was actively involved in the early Impressionist exhibitions, and became a dedicated archaeologist. His black hat all but covers a distant statue representing the city of Strasbourg, recently lost to Prussian forces and the focus of national remorse. It is difficult to think that the masking

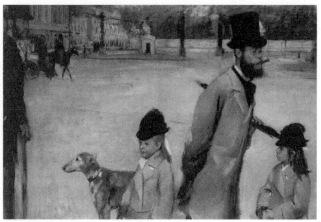

Degas, *Place de la Concorde: Vicomte Lepic and His Daughters*, 1875

is accidental. The square had successively been known as the Place Louis XV, de la Revolution, de la Concorde, Louis XV again, and finally Place de la Concorde for the second time. Thousands had been guillotined there in 1794. It was a place saturated in French history. The vicomte, like Degas and the Impressionists, is pursuing his independent path.

The insubstantiality of Monet's Impressionism was a problem that bothered some of the avant-garde as well as the traditionalists. Monet himself sensed this when undertaking his paintings of Rouen Cathedral and Haystacks in the 1890s. But he remained dogmatically untheoretical.

The most intense effort to transform Impressionism into a quasi-scientific system was the 'divisionism' of Georges Seurat, exemplified in what may be regarded as his manifesto picture, *A Sunday Afternoon at the Island of the Grande Jatte* (overleaf), the laborious execution of which

lasted from 1884 to 1886. In some ways it is a throwback. At almost 7 by 10 feet, and given its calm monumentality, it challenges the *grandes machines* of history painting at the Academy and departs from the domestically scaled pictures that had become the norm for Impressionists. In 1886 it dominated the Salon of the Society of Independent Artists, which Seurat had helped to found. Cézanne and Gauguin were participants.

It is worth beginning with content, because discussions tend to be skewed towards its colour technique. The Parisian bourgeoisie are on parade in the sun of the manicured island, wearing their Sunday best and comporting themselves with a self-conscious rectitude that Seurat underlines through his insistent use of profiles. The perspectival scaling of the figures and columnar trees recalls classic art, not least that of the Renaissance. Seurat belonged to this world of formal manners, but harboured anarchist views, and we sense the irony with which he mocks the conventions of a rising social class on their afternoon away from work, religion and politics.

For this modern subject, the colouristic technique is as modern as it can be. Seurat has transformed the divided brushwork of Impressionism into a set method that aspires to exploit the latest scientific ideas on colour vision. His most trusted source appears to have been the American scientist Ogden Rood. Seurat seeks not to blend colours on his palette or on the canvas, but to mix them optically. This relies upon the relatively new distinction between subtractive and additive primaries. Pigments work by absorbing colours selectively from the compound that makes white light. The

Seurat, *A Sunday Afternoon at the Island of the Grande Jatte*, 1884–6

three basic primary colours for pigments, yellow, red and blue, each subtract different bands of the spectrum. The greater the number of pigments that are mixed, the darker the mixture becomes. Mixing coloured lights adds colours, and a sufficient mixture will produce white light. Through his technique of applying a host of distinctly coloured points that would each reflect coloured light, Seurat was aspiring to mix the lights in the air and in the eye of the observer. He also worked to contrast complementary colours – red against green, blue against orange – and to enhance dark edges with bright fringes and vice versa. Thus, what he calls 'solar orange' is set off against bluish shadows. Dark forms are surrounded by light haloes. If the results appear to be less radiantly luminous than he hoped – particularly given the deterioration of key pigments – the large canvas does still shimmer. It should also be said that Seurat does not produce a series of uniform dots of colour across the canvas. The

directions of the short brushstrokes respond to the forms, and there is a good amount of covert outlining. However, it remains a bewitching painting, socially and technically.

Other members of the Independents took independent paths. Paul Cézanne's has proved to be one of the most appreciated and difficult to describe. A series of pronouncements are commonly rolled out to explain what he was doing. He is said to have 'wanted … to make of Impressionism something solid and durable, like the art of the museums'. 'Imagine Poussin remade entirely on the basis of nature'. 'I do not want to reproduce nature, I want to recreate it.' 'Interpret nature in terms of the cylinder, the sphere, the cone; put everything in perspective, so that each side of an object, of a plane, recedes towards a central point'. He is reported to have said these things, mainly by the painter Emile Bernard, but Bernard wanted to emphasise the classic, Poussinist nature of Cézanne's enterprise. Cézanne's heroes appear to have been sculptors, above all Michelangelo, together with Rubens and Delacroix. He seems to have been non-programmatic and pragmatic.

Looking at the *Still Life with Apples, Basket, Bottle and Biscuits*, exhibited in Paris in 1895, we can feel how the assertively unrefined contours, and the bold wedges, stabs, hatchings and broken arcs of percussive colour grant the objects a sense of physical presence – but it is difficult to say why. How is it that the downward fracture of the top of the table to the left of the basket works to assert the sloping basket's contents? Why is it obviously right that the bottle of wine leans towards the basket? Why does the higher line of the near edge of the table at the right help to make the single

Cézanne, *Still Life with Apples, Basket, Bottle and Biscuits*, 1895

isolated fruit (a pear?) terminate the cluster so effectively? What do the ungracious creases in the white cloth do to make the apples so rosy and concrete? Why are the stacked biscuits so tangible? Somehow, strong paint becomes an active agent in the act of seeing, as Cézanne looks with long intensity at the architecture of his contrived tableau, using colour to render structure. We need to look hard, joining Cézanne in his visual exploration, aware that his seeing and representing remains provisional. There is always what he called the 'residue of the inexplicable'. Again the spectator's job has been redefined.

The ennobling of simple things was a key aspect in the legacy of Courbet and Champfleury. The 'primitive' and the 'alternative' could be folksy and French, or exotic in time and place. Vincent van Gogh, like other artists in the

wake of the Realist and Impressionist revolutions, looked towards both. It was the search for something simple, basic and honest that brought van Gogh, former Dutch art dealer and missionary, from two years in sophisticated Paris to the southern country town of Arles in February 1888. There he hoped to recover his health, refresh his artistic vision and found a colony of like-minded artists. He moved into a little yellow house on an angled corner at 2 Place Lamartine. It marked the start of two years of intense creativity, joy, hope, anguish and mental disturbance. The first of his Parisian acquaintances who intended to visit was Paul Gauguin. Van Gogh began to plan enthusiastically, painting one of his famous series of *Sunflowers* for his friend's room. On 17 Oct 1888 he wrote to Gauguin about a painting of his own bedroom:

> I did, for my decoration once again, a no. 30 canvas of my
> bedroom with the whitewood furniture that you know. Ah,
> well, it amused me enormously doing this bare interior. With
> a simplicity à la Seurat. In flat tints, but coarsely brushed
> in full impasto, the walls pale lilac, the floor in a broken
> and faded red, the chairs and the bed chrome yellow, the
> pillows and the sheet very pale lemon green, the bedspread
> blood-red, the dressing-table orange, the washbasin blue,
> the window green. I had wished to express *utter repose* with
> all these very different tones, you see, among which the only
> white is the little note given by the mirror with a black frame
> (to cram in the fourth pair of complementaries as well).

This first version was damaged by flood and he began a second, now in Chicago, very similar to the first but with a lighter-toned floor. The colours are not determined by

literal matching but contrived to capture the emotional essence of the room through pairs of 'opposite' colours that enhance each other – lilac and chrome yellow, lemon green and red, orange and blue, and black with white. Each of the major coloured components is set up with emphatic outlines, so that they sound out like distinct instruments playing a tuneful passage in a brass band. His interest in flat

VAN GOGH

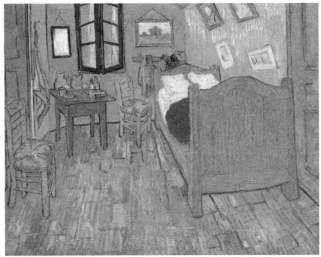

van Gogh, *Bedroom (at Arles)*, 1889

and outlined planes of colour was stimulated by Japanese woodcuts, which also introduced him to alternative ways of depicting space.

The space in the *Bedroom* would hardly win approval from a theorist of perspective, but is less eccentric than it looks. The actual end wall was indeed skewed at an angle. The furniture stands with more obstinate conviction in space than if it were planned with perfect geometrical exactitude, but he does not radically violate the rules. The clearest departure comes with the patterning of the floor towards the base of the frame, which rises diagonally towards the right border as the painter's eye turns to encompass as much of the full extent of the constrained space as possible.

Gauguin arrived but the relationship rapidly plummeted, culminating in the legendary incident in which part

of van Gogh's ear was severed, probably in an act of self-mutilation. In any event, Gauguin returned to Paris and the bleeding van Gogh was hospitalised.

Underlying the personal friction were different views of art. For van Gogh, a painting spontaneously recreates a visual experience in enhanced colour and space to convey emotion. Paul Gauguin looked to a more synthetic vision, in which memory acts as a filter, constructing meaning in a symbolic manner. His personal search for a 'primitive' key to 'real' art and a 'savage' society took him to Tahiti in 1891. After a brief return to Paris in 1893–5, he returned to the South Seas for the rest of his life, never finding the enduring contentment that he sought.

As with Courbet and Seurat, Gauguin provided what may be regarded as a manifesto painting – indeed, a manifesto on the human condition. *Where Do We Come From. What are We. Where Are We Going*, painted in 1897, is over 12 feet long and assumes the form of a frieze, in the manner of a polychrome woodcarving. Gauguin did not provide a complete guide to the symbolism, but dropped some hints, including an indication that it should be read from the left. He said that the wizened old woman on the left, who is 'approaching death' appears 'reconciled and resigned to her thoughts', and that the odd white bird at her feet 'represents the futility of words', which does not encourage us to think that the meanings are obvious. The handsome young woman looking at the bird is of a recurrent type in Gauguin's Tahitian paintings and sexual life. The luminous blue goddess represents what the painter called 'the Beyond'. The statuesque woman stretching to

pluck an apple from the very top may allude to Eve's sin. An 'innocent' boy bites into the forbidden apple to the left. The seated man (?) seen from the rear may be inspecting his underarm for signs of puberty. The two younger girls, eyeing us seductively, with the dusky young man, comprise a kind of Tahitian *fête champêtre*. The sleeping child signifies new life, but its deep slumber prefigures death. The tone is enigmatic and fatalistic.

The draughtsmanship is several degrees more 'savage' than anything attempted by van Gogh. The flattened colours and illogical space are further detached from naturalism. Like Courbet's *Studio*, Gauguin's painting is an allegory, but its only claim to reality is that of the inner truth of the artist's own diagnosis of the human condition in his island 'paradise'. He stated that 'this canvas not only surpasses all my preceding ones, but that I shall never do anything better – or even like it'. Its completion was followed by what he said was a suicide attempt.

Gauguin also undertook sculpture, most strikingly some 'primitive' woodcarvings that could not have been in sharper contrast to the classicising mainstream. The

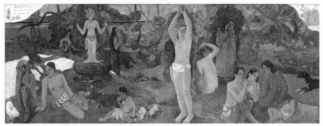

Gauguin, *Where Do We Come From. What are We. Where Are We Going*, 1897

great public challenge to classical orthodoxy came from a sculptor who was immersed in the great tradition but not subservient to it. Auguste Rodin conducted a profound visual dialogue with Michelangelo and ancient sculpture, seeking a means of sculpting the human figure that spoke to his own times. In doing so, he ran into sustained opposition.

Rodin's *Burghers of Calais* was an official commission and represents a historical subject, but it is assertively non-traditional. Following a competition in 1894, Rodin was commissioned by the city of Calais to sculpt a monument commemorating self-sacrifice by citizens. The events of

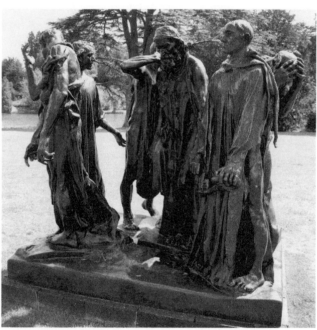

Rodin, *The Burghers of Calais*, 1884–9

1346 are recounted in the *Chronicles* of Jean Froissart. He tells how the English king, Edward III, decided to starve Calais into submission during a siege and then decreed that six of the leading citizens should 'come out bare-headed, barefooted, and bare-legged, and in their shirts, with nooses about their necks; with the keys of the town and castle in their hands.' Froissart then tells how

> The richest burgess of all the town, called Eustace de Saint-Pierre, rose up and said openly: 'Sirs, great and small, a great misfortune it should be to suffer to die such people as are in this town, by famine or otherwise, when there is a means to save them. I think one or more of us will acquire great credit from our Lord God by protecting them from such misfortune … I will be the first to put my life in jeopardy'.

His stoic example was followed by five other leading burghers. In the event, their lives were spared by the victor.

Rodin's models for the monument provoked hostility. The council expected a heroic group with Eustache at the summit of the composition. Rodin responded

> I read again the criticisms … which would emasculate my work; the heads to form a pyramid (the Jacques-Louis David method) instead of a cube (straight lines), means submitting to the law of the Academic School. I am dead against the principle, which has prevailed since the beginning of this century but is in direct contradiction with previous great ages in art and produces works that are cold, static and conventional.

Rodin won that battle to use his 'cube' but not the one to eliminate a pedestal.

> I wanted them to be placed on, even affixed to, the paving stones of the square in front of the Hôtel de Ville in Calais so that it looked as if they were leaving in order to go to the enemy camp. In this way they would have been, as it were, mixed with the daily life of the town.

The heroism of Rodin's figures is not conventional but resides in human tragedy. The bearded Eustache, calmly melancholic, is surrounded by his sacrificial companions, each reacting in a different way, just as Leonardo had diversely characterised the 'motions of the mind' of the disciples in his *Last Supper*. The poses and expressions, as with Michelangelo, well up from within. Jean d'Aire, rigid in resolution, holds the keys in front of him; Andrieu d'Andres claws at his skull. The youngest, Jean de Fiennes, exudes poised innocence. They run the gamut of emotions. Rodin does not so much tell the story – they are not literally marching out of the city. Rather, they gather to act out their sacrificial theatre within a cube of pain.

The surfaces are not buffed smooth in the classical manner, but bear witness to the expressive urgency with which Rodin pummelled and sliced the wax from which the bronze was cast. The surfaces catch the light in jagged patches. A new kind of sculpture has been born.

We have seen the arrival of modern life in large-scale art. The time-honoured narrative subjects that were thought appropriate for big art were being replaced by the kind of everyday subjects that had been largely confined to smaller genre paintings. This move was accompanied by harsher

modern styles that violated the formal and colouristic norms of the academies.

Although the reformulation of the relationship between artist and spectator has been told here only through masterpieces by French artists, this does not mean that nothing of importance is happening elsewhere. It does, however, acknowledge that the key moves were manifested most vividly in France in the last half of the nineteenth century. It is not easy to explain why.

BRAQUE

PICASSO

8
NEW EXTREMITIES

From the *Manifesto of Futurism*, 1909, by the writer Filippo Marinetti:

We want to sing the love of danger, the habit of energy and daring …

We declare that the magnificence of the world has been enriched by a new beauty: the beauty of speed. A racing automobile with its bonnet adorned with great tubes like serpents with explosive breath … a roaring motor car which seems to run on machine-gun fire, is more beautiful than the Victory of Samothrace …

We are on the extreme promontory of the centuries! What is the use of looking behind us when we desire to open the mysterious doors of the Impossible? Time and Space died yesterday. We are already living in the absolute, since we have already created eternal, omnipresent speed …

We want to glorify war – the only cleansing for the world – militarism, patriotism, the destructive gesture of the anarchists, the beautiful ideas that kill, and contempt for woman.

We want to demolish museums, libraries, academies of every kind, and to fight against morality, feminism and all opportunist and utilitarian cowardice.

We will sing of the great crowds agitated by work, of pleasure and of revolt; we sing of the multi-coloured and polyphonic seas of revolutions in modern capitals: we sing of the nocturnal and fervent vibration of the arsenals and the workshops lit by their violent electric moons: the gluttonous stations devouring serpents that smoke; factories suspended from the clouds by the twisted threads of their smoke; bridges leaping like giant gymnasts flung across the rivers, flashing at the sun with the gleam of cutlery...

Creative individuals do not always fit the patterns beloved of historians. One such individual, self-professedly so, was Edvard Munch. He created one of the great icons of 'modern art' in Oslo. The last chapter would lead us to expect this to occur in Paris. As it happens, Paris does play a role. On his first stay in Paris in 1889, Munch encountered what Paris could offer, including the expressive manipulations of form, colour and space by van Gogh and Gauguin.

Munch sought a manner of painting that expressed the well-advertised angst of his personality. He always sensed the precipice of insanity. There is no shortage of pronouncements: 'The angels of fear, sorrow, and death stood by my side since the day I was born'. 'I inherited two of mankind's most frightful enemies – the heritage of consumption [tuberculosis] and insanity'. The spectre of poor physical and mental health accompanied him through life. Like van Gogh, he held cerebral views about the functioning of art.

The iconic picture is of course *The Scream* (overleaf), though a better translation of Munch's own title is *The Shriek of Nature*. He wrote about it in poetic form on the frame of the 1895 version.

I was walking along the road with two friends
The Sun was setting – the Sky turned blood-red.
And I felt a wave of Sadness – I paused
tired to Death – Above the blue-black
Fjord and City Blood and Flaming tongues hovered.

My friends walked on – I stayed
behind – quaking with Angst – I
felt the great Scream in Nature

The two friends are apparent at the left edge of the picture, walking across an elevated bridge or viaduct above a curving inlet of dark sea. However, in the 1893 painting they seem to be walking towards the screamer. The sky is blood red, less a meteorological effect and more an evocation of a mental state. The aggressive diagonal streaks of paint of the road and railings clash with the elemental curves of the earth, water, air and fire. The impact of Gauguin is evident on the pictorial language.

The shrieking figure represents Munch, but not as a portrait. The artist's soul is imprisoned in a silhouette that is almost foetal, or, as has been suggested, like that of a Peruvian mummy he could have seen in Paris or Florence. The mummies – hollow eye sockets and gaping mouth – hold their heads in cupped hands. The Parisian mummies had been even more closely emulated in Gauguin's *Where Do We Come From*.

There are four versions in various media: two using paint and mixed media in 1893 and 1910, and two in pastel from 1893 and 1895. That Munch could complete the near-copies without significant loss of power dispels the idea that the original painting was undertaken in an irrational transport of terror. The terror was genuine, but realised through a full control of artistic means.

What follows in the twentieth century is a series of initiatives striving to define the true role of art – often pushing possibilities to extremes. We encounter a series of movements and …'-isms': Cubism, Fauvism, Expressionism, Futurism, Dada, Surrealism, De Stijl, Abstract Expressionism and Minimalism, to name a few.

Munch, *The Scream (The Shriek of Nature)*, oil, 1893

In tackling this plethora of re-definitions, much will be omitted, but our strategy of looking for radical changes in the axis of artist-work-spectator will direct us towards major innovations.

Space and time are deeply involved in the new visions. The notion of the painting as a kind of window had persisted

from the Renaissance to the end of the nineteenth century. Cézanne, van Gogh, Gauguin and Munch introduced some severe distortions to the glass, but the frame remained. The dissolution of the standard notion of the picture was achieved in tandem by Pablo Picasso and Georges Braque in Paris in 1910–12 in their invention of what came to be called Cubism. They abandoned fixity of viewpoint and definition of form through continuous contours and shading. They no longer viewed the subject at a definable moment in space and time. In doing so, they effected a revolution in its own way as profound as relativity in physics. There is some evidence that they were alert to what was happening in mathematics and physics, most notably the multi-dimensional geometry of Henri Poincaré, and the redefinition of the relationships between space, time, energy and mass in Einstein's theories of relativity. The relationship between the new sciences and Cubism is not as direct as that between optics and linear perspective. Rather, Picasso and Braque became aware of some popular accounts and illustrations of the new ideas and bent them to their agenda of forging a new kind of reality in art. The way that the foundational works of Cubism, especially still lifes and portraits, exploited faceted surfaces is very like some of the illustrations in Esprit Jouffret's *Elementary Treatise on Four-Dimensional Geometry* in 1903. However, they were not illustrating the science.

Picasso and Braque fractured the contours and planes of an object, as if form and space have been crushed and reconstituted in an alternative order. Objects and backgrounds are a series of angular shards, overlapping and

interpenetrating. We sense the presence of Cézanne behind the attention Picasso gives to defining angular planes with blunt brushstrokes.

The work selected overleaf, from later in Picasso's career, exploits the radical vision of form fostered in Cubism but is far less cerebral. *Guernica* is another large-scale 'manifesto' painting, in this case a manifesto of Picasso's role as the leader of modern art and, belatedly, as a Spanish patriot. In as much as different stages in its execution were photographed, it also represents the self-conscious performance of the artist as an autonomous genius.

Early in 1937, Picasso was approached by representatives of the Spanish Republican government, then fighting against the Nationalist forces of General Franco. The government wanted Picasso to paint a propaganda piece for the Spanish pavilion at the forthcoming World's Fair in Paris. In April the strategically unimportant Basque town of Guernica was savagely bombed by the German fascist air force on behalf of Franco. Picasso reacted to the gratuitous slaughter by planning a mural-sized canvas, over 25 feet long.

There are some eight victims of the fascist bombs, including two animals, a shattered warrior, and four screaming women, one of whom holds a dead child – a new kind of Massacre of the Innocents. Picasso uses tiled flooring to establish a shallow stage for his actors. Starting at top left, we see that most Spanish of animals, a bull, staring desperately at us with two frontal eyes. Beside the bull is the outline of a shrieking dove. Below it are the contours of a woman, contorted in paroxysms of grief as she grasps her broken baby. At the top, a harsh electric lamp blazes

eye-like with an incendiary glare, in contrast to the modest oil lamp held by a trapped woman who oozes through a small window in the burning house. An agonised horse has been run through by a spear. Its body seems to be patched together from passages of summarily painted newsprint. At its feet are hollow fragments of a fallen warrior, his hand clenched in rigor mortis around his fractured sword. One of the three women on the right seems to have staggered from the burning house, within which her companions are to die horrible deaths.

The blacks, greys and whites are those of a newspaper photograph, sombre and documentary. However, the painting is not an illustration of Guernica in any specific sense. It is a protest against the criminality of war on behalf of defenceless victims. Picasso himself discouraged detailed iconographical analysis of an academic kind. He invites us to bring our personal readings into his house of horrors.

Picasso's great rival as the standard-bearer for a new type of painting was Henri Matisse. Their rivalry echoed that of Delacroix and Ingres, though with a mutual respect that lead

Picasso, *Guernica*, 1947

back-and-forth in the forging of their styles. Their pictorial philosophies were radically different. In contrast to the jagged visual expression that was Picasso's most enduring mode (among many), Matisse adhered to Delacroix's view that a painting should be a 'feast for the eyes'.

> What I dream of is an art of balance, of purity and serenity, devoid of troubling or depressing subject matter, an art which could be for every mental worker, for the businessman as well as the man of letters, for example, a soothing, calming influence on the mind, something like a good armchair which provides relaxation from physical fatigue.

We would be mistaken, however, if we took this for easy complacency. Matisse aims at a new level of joy in painting based on a radical pictorial vocabulary – a very new style of armchair. When he exhibited in the Parisian art scene with like-minded painters in 1905 – before Picasso had found his Cubist voice – their freedoms of colour, form and space were so extreme that a critic described them as *fauves*, 'wild beasts'. Their colours appeared arbitrary and anarchic; their drawing primitive; their spaces incoherent. Like the Cubists, the Fauvists were emerging from the shadow of Cézanne, but looked to the older painter's colour rather than his structural draughtsmanship.

At almost 8 feet wide, Matisse's seminal *Le bonheur de vivre (The Joy of Life)* of 1905–6 is a *grand machine* in the tradition with which we are familiar. It is both conservative and revolutionary. It retains the idea of the picture as a window; it draws richly on historical precedents; and in general looks to the old and much-referenced genre of

the *fête champêtre*. The round of dancing figures refers, surprisingly, to Ingres' painting of the *Golden Age*, exhibited in the Ingres exhibition of 1905. The overall set-up is based on a late sixteenth-century print of love making in the countryside by Agostino Carracci. On the revolutionary side, the colour is even less naturalistic than Munch. Reds blaze where Matisse chooses in order to make his picture sing. The dark haloes around the 'odalisques' in the mid-ground allude to Seurat's optical techniques, but are used for their independent colouristic punch. Rhythm asserts itself over space whenever Matisse decides it should. Where sunny joy is needed, he simply applies a vivid yellow. *The Joy of Life* was purchased by Gertrude and Leo Stein, Americans in Paris, who were accumulating an art collection containing works by almost everyone who mattered in the avant-garde, including Picasso, who responded competitively to Matisse's innovatory canvas with his disruptive *Les Demoiselles d'Avignon* in 1907.

JOYOUS PICTORIAL VOCABULARY

MATISSE

There were more strident voices in the advocacy of a new art, none more so than the moustachioed poet and fiery mouthpiece, Filippo Marinetti. He was the literary leader of the Italian Futurists. The movement involved visionary architecture, cacophonous music, riotous literature, dynamic painting and explosive sculpture. Marinetti's

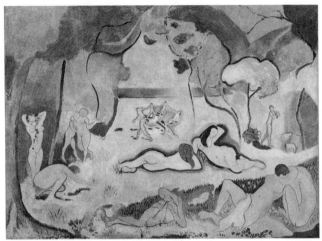

Matisse, *The Joy of Life*, 1905-06

manifestos are both thrilling and chilling. They are repellent in their macho hyperbole, sexism, intolerance and destructiveness, qualities that do much to explain Marinetti's later alignment with Fascism.

The Futurists issued a series of passionate declarations, including technical manifestos for painting and sculpture by Umberto Boccioni, the most creative and versatile of the group. His assertive writings were liberally laced with new phrases, printed in capitals – UNIVERSAL DYNAMISM, INTERPENETRATION OF PLANES, EXTERIOR and INTERNAL PLASTIC INFINITE, PHYSICAL TRANSCENDENTALISM, INVISIBLE INVOLVING SPACE. The tone was scientific but in a poetic rather than technical sense.

Boccioni and his colleagues immersed themselves in the aura of new space-time in physics, but translated

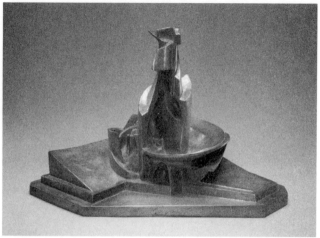

Boccioni, *Development of a Bottle in Space*, bronze, 1913

it into something that was more psychological than mathematical. The leading painters, including Giacomo Balla and Gino Severini, adapted the fragmented forms and spaces of Cubism to express the dynamics of figures and objects in strident motion. Remarkably, Boccioni was able to carry the dynamic vision of his paintings into sculpture. His *Development of a Bottle in Space* persuades the solid medium of bronze to express or at least suggest a series of relativities. Form, space and light are evoked as interpenetrating energies rather than as separate physical entities. The spaces occupied by the bottle and the observer become interactively fused as the interior and exterior of the bottle interpenetrate with the surrounding medium. We are invited to view the bottle unwrapping in space-time. Boccioni wanted to make the bottle's 'extension into space, palpable, systematic and plastic'.

Radical revolutionary overthrowing of the established order characterised the two biggest international movements of the second and third decades of the new century: Dada and Surrealism. It is unsurprising that extreme politics were involved – not this time the incipient fascism of Futurism but the anarchism favoured by the Dadaists and the communism associated with the Surrealists.

With Dada it is easier to say what its protagonists were against. They were against the past and the status quo. They were against 'Art' and 'Artists'. They did not favour standard media. Their rule was no rules. They were seriously non-sensical. Dada itself was a nonsense name. The tendency was not centred initially in Paris, but in wartime Zurich and New York. Its most conspicuous literary advocate was the Romanian writer and scandalous stager of performances, Tristan Tzara. His Dada

> expresses the knowledge of a supreme egoism, in which laws wither away. Every page must explode, either by profound heavy seriousness, the whirlwind, poetic frenzy, the new, the eternal, the crushing joke, enthusiasm for principles, or by the way in which it is printed. On the one hand a tottering world in flight, betrothed to the glockenspiel of hell, on the other hand: new men.

The New York 'branch' of Dada is famed for the anarchic presence of Marcel Duchamp and his iconic *Fountain*. In 1917 he submitted his manufactured urinal to the Society of Independent Artists in the city, lying on its back and signed untidily by 'R. Mutt'. They rejected it, which seemed to be against their rules. It is now seen as a defining work of the twentieth century – the definitive 'ready-made'. Its

THE FIRST RULE OF DADA CLUB IS THERE ARE NO RULES!

rejection, like that of Monet's *D e j e u n e r*, brought it fame. The Dadaists journal, *The Blind Man*, railed in an editorial that, 'whether Mr Mutt made the fountain with his own hands or not has no importance. He CHOSE it. He took an article of life, placed it so that its useful significance disappeared under the new title and point of view – created a new thought for that object'. By renouncing the object's *function* Duchamp potentially transforms it into the focus for *aesthetic judgement*. We could conduct a formal analysis. Look at the satisfying relationship between the four little holes in a vertical line and the triangular cluster of six holes. Isn't it nice the way that the curvaceous sweep of the rim culminates in the protruding 'O' of the mouth …? This is, of course, silly, but it highlights Duchamp's radical question about defining a work of art and challenges the whole business of writing about art. Duchamp is urinating on the art world – but he is absolutely dependent on it for his impact.

The 1917 'original' was lost, but a series of replicas were ordered by Duchamp from 1950 onwards, and sold to august museums for handsome prices. Either way, rejected or accepted, he could not lose.

Surrealism was a diverse movement that took hold on a widespread basis in Europe and America. The Surrealists were not so much anti-art as seeking an entirely new mental reality for the creative act. We have seen the rise of earlier ideas about the artist's imagination, genius and soul. These were subsumed by the theorists of Surrealism within the deep subconscious, from which the strange reality of

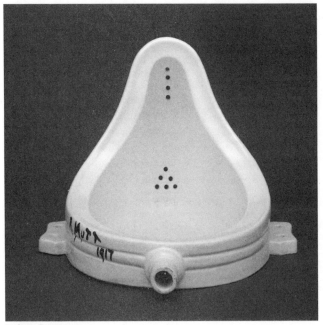

Duchamp, *Fountain*, 1917

dreams emerges. Sigmund Freud's psychology was hugely important. The driving force of the earliest phases of Surrealism was literary, psychological and philosophical rather than painterly. The logic of rationality was to be replaced by the dream-like conjoining of things and fragments of things that never belong together in our sober experience.

The leader was the experimental author, André Breton, who had trained in medicine and psychiatry. His 'automatic writing' set the tone. It consisted of an unpremeditated outpouring of words that emerged spontaneously from obscure corners of the mind. He followed this with 'automatic drawing', of which André Masson was the most enthusiastic proponent, under the influence of bodily depravations and mind-changing substances. Breton's 1924 manifesto of Surrealism presented ironically sober definitions, styled on works of reference.

> Dictionary:
> Surrealism, n. Pure psychic automatism, by which one
> proposes to express, either verbally, in writing, or by any
> other manner, the real functioning of thought. Dictation of
> thought in the absence of all control exercised by reason,
> outside of all aesthetic and moral preoccupations.
>
> Encyclopedia:
> Surrealism. Philosophy. Surrealism is based on the belief
> in the superior reality of certain forms of previously
> neglected associations, in the omnipotence of dream, in the
> disinterested play of thought. It tends to ruin once and for all
> other psychic mechanisms and to substitute itself for them in
> solving all the principal problems of life.

Surrealist thinkers generated a powerful written output of rabble-rousing publicity and publications, including their own journal, *La Révolution surréaliste.*

In addition to Masson, Surrealism attracted significant visual artists from many countries, including the French Yves Tanguy and Francis Picabia, the Italian Giorgio di Chirico, the Germans Max Ernst and Paul Klee, the Spaniards Joan Miró, Salvador Dalí and Luis Buñuel, the Belgian René Magritte, the Swiss Méret Oppenheim and Alberto Giacometti, and the American Man Ray.

Salvador Dalí strove to render the inverted realities of dreams. He also signals a new kind of artist for whom their public profile becomes a work of art in its own right. Like Picasso, he pioneered the artist's role as media celebrity, his reputation fuelled by strategic notoriety. Fertile,

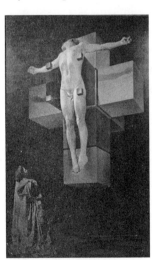

Dalí, *Corpus Hypercubus (Crucifixion)*, 1954

imaginative, mystical, religious, opportunistic and self-obsessed, Dalí devoured ideas, including the new theories of space and time. His *Crucifixion* (*Corpus Hypercubus*) exemplifies the way in which he exploits his prodigious technique to give visual reality to the unseen and incongruous. It also bears witness to his annexing of advanced science. Christ is undergoing a four-dimensional crucifixion on a

hypercube of the type devised by Charles Hinton, the eccentric American-based mathematician.

We can unfold a standard cube as a flat template, which provides the tiling pattern on the ground in Dalí's picture. If we unfold a hypercube, the result, as Hinton envisaged, would be a cruciform tesseract of the kind on which Dalí pinions his Christ, whose unmarked body fuses with the foremost cube. Mary Magdalene, in the substantial presence of Dalí's wife, Gala, witnesses the multidimensional vision on our behalf. On the horizon a tinge of light progressively yields to the black infinity of the void above. Dalí manages that difficult trick of being difficult and popular at the same time.

Alongside the moves into extra dimensions, mental and physical, we witness increasingly insistent assertions of the essential flatness of painting – something that Picasso sometimes exploits without it becoming his chief aim. A highly programmatic expression of flatness, and an assertion of pure abstraction occur in Piet Mondrian's work soon after his return to Paris in 1919. He had encountered Picasso's innovations in Paris before the war, and in the intervening years in Holland had founded the movement De Stijl (The Style) with the architect, designer and writer Theo van Doesberg. They distilled the pure visual components of art as basic lines

and primary colours. For Mondrian this gave pictorial expression to the doctrines of Theosophy, a metaphysical system that strove to excavate the most profound spiritual truths that penetrate matter and soul at the local and cosmic levels. Mondrian was in effect seeking to create modern spiritual icons – absolute and timeless.

He explained that 'through horizontal and vertical lines constructed with awareness, but not with calculation, led by high intuition, and brought to harmony and rhythm, these basic forms of beauty ... can become a work of art, as strong as it is true'. This is what he called Neo-Plasticism, a new way of realising art through irreducibly basic elements. He saw pure abstraction as profoundly in

Mondrian, *Composition with Yellow, Red, Black, Blue and Grey*, 1920

tune with modern consciousness. His composition from 1920 in the Stedelijk Museum is an early example of what became a typical Mondrian. The grid of rectangular bars, abruptly abutting, coincides with flat rectangles of primary colours, accompanied by white, black and grey. We know from unfinished paintings that the inexplicable rightness of the balance was hard-won during a nervy process of experimental manoeuvring. Genuine Mondrians exude a sense of 'rightness'.

Even more radical is Kazimir Malevich's *Black Square*, painted as early as 1915, at a time of political and cultural

Malevich, *Black Square*, 1915

ferment in Moscow, where the innovations of Cubism were avidly received by avant-garde artists. In the same year Malevich founded the Suprematist movement as an artistic collective. As with De Stijl, Suprematism strove to reduce painting to the basics of form and colour in a way that its adherents saw as enriching visual experience: 'every real form is a world. And any plastic surface is more alive than a … face from which stares a pair of eyes and a smile'. The plastic surface of *Black Square* (now rather cracked) is an extreme assertion of the work of art as an open field for interpretation. It is also an extreme assertion that whatever the artist chooses to call a work of art is a work of art. Malevich took the traditional notion of the sublime, developed in relation to our experience of nature in the late eighteenth century, and abstracted it as a form of pure mental contemplation. He set an unyielding agenda.

The agenda of flatness and abstraction was taken up by a heroic generation of New York artists. The centre of innovation was shifting. The high priest of the American ideal was the critic Clement Greenberg who declared that a painting should assert itself as a painting. It is paint on a surface, preferably large and all-embracing. It was to be detached from the illusion of real things, and needed to work strictly on its own irreducible terms. As Greenberg wrote in a later gloss to his 1960 essay *Modernist Painting*,

> I regard flatness and the inclosing of flatness not just as the limiting conditions of pictorial art, but as criteria of aesthetic quality in pictorial art; that the further a work advances the self-definition of an art, the better that work is bound to be.

What he had in mind were the paintings by an emergent group of declamatory painters who became known as the Abstract Expressionists, including Barnett Newman and Robert Motherwell, who were applying bold areas of paint abstractly on huge canvases.

The most visually seductive of the pioneering painters was Mark Rothko, who moved decisively in the years 1946–8 from a kind of biomorphic surrealism with abstract tendencies to fully fledged colourist abstractions. A typical Rothko is large enough to be immersive – he recommended very close viewing – and is to be hung close to the floor. We are presented with floating walls of colour in blurred rectangular fields that seep towards us like light from stained-glass windows. At the same time the top layer of modulated colour seeps into the underlayers. His technique is complex and unique. An unprimed canvas is tinted with a layer of binder and pigment, on to which he wafts thin layers of colour dispersed in a variety of fast-drying binders. As he declared, the result is that 'my paintings' surfaces are expansive and push outward in all directions, or their surfaces contract and rush inward in all directions. Between these two poles, you can find everything I want to say'. He wanted paintings to communicate 'basic human emotions — tragedy, ecstasy, doom, and so on'.

Ecstasy is a common tone in his earlier abstractions. *No. 14* (given an opus number like a piece of music) sings out with an indeterminate red-orange glow, set with perfect pitch against the elusively assertive blue that floats amorphously above a black substrate. The effect is uplifting. But the doom and tragedy that he saw as haunting his

personal and professional life is always in the background. The chapel he undertook in Houston, dedicated in 1971 one year after the artist's suicide, houses a series of large sombre canvases on the walls of an octagon – the shape inspired by the Byzantine church of St Maria Assunta on the Venetian island of Torcello. Again we sense the dark void, whether nihilistic or transcendentally spiritual. Regular meditators in the chapel testify to the latter, but I felt only the former.

Rothko, *No. 14*, 1960

The most overtly provocative of the New York artists was Jackson Pollock. The provocation did not just lie in uncompromising abstraction but in a painting process that seemed uncontrolled.

There are films of Pollock in action. A long, loose rectangular canvas lies on the floor or the ground. There are cans and containers full of varied kinds of liquid paint. He has brushes and sticks, clotted with pigment, that are plunged into the liquid mixtures. He stalks restlessly around the four edges of the canvas, rapidly ducking and bobbing, reaching out with his brushes and sticks, dripping, splattering, and streaking dynamic tracks and blots of colour. He is like an animal obsessively marking its territory with identifying sprays. Sometimes the paint dribbles from holes in tins that are swung on strings. The process is instinctual, yet there is a method. Pollock stares with intense concentration, making urgent choices about where to lay different coloured tracks in relation to unmarked sections of canvas and pre-existing marks (the earliest of which are

Pollock, *Autumn Rhythm No. 30*, 1950

often black). Instinct and deliberation interact at a speed that is in effect simultaneous.

The way the paint settles on the surface involves a complex compound of control and unpredictability. The results are not random. The parameters – the probabilities – are set by choices of material, applicator and action but the detailed behaviour of the paint cannot be predicted precisely. It is the prominence of unpredictability that proved so shocking, as if the artist was abrogating control and doing something anybody could do. As it happens, paintings by Pollock have proved to exhibit characteristics shared with fractals, most specifically with respect to how, if we zoom into progressively smaller areas, the marks fill space at the different scales in essentially the same manner. I doubt whether you or I could achieve this result.

All this would be of no account if the results were not thrilling. When a painting is eventually hung, we are confronted by a vibrant wall of unquenchable energy, expressed in micro- and macro-rhythms of disorder. His *Autumn Rhythm*, more than 17 feet wide, does not represent autumn in any obvious sense, but creates its own kind of autumnal chaos as phenomenon parallel to nature. His paintings present endless inexhaustible fields of stimulation for the eye, mind and (by a process of empathy) our body.

The standard notion of sculpture was that it is about mass, even if opened up in the Boccioni manner. This traditional concept was not exhausted, as notably demonstrated by the great organic semi-abstractions by Henry Moore. However, radical alternatives were forged, none more radical than the 'mobiles' of Alexander Calder, in which smallish

components, such as plates, fins and balls, are suspended with rods and wires in subtle arrays of compound balance that gently sway and swirl in space. There is no consolidated bulk.

Trained as an engineer, Calder went to Paris in 1926, where he encountered Miró, Duchamp, Mondrian and other leading figures of the avant-garde. He was a man of fertile visual wit and invention, fabricating idiosyncratic toys and a portable circus of pert performers in wire and wood. He liked things to move. By 1931 he had arrived at what are his signature works, the 'mobiles', christened as such by Duchamp. The example illustrated here of an early mobile is simpler than many later examples, but all the essentials are there. A lateral ball, not that large, balances a compound unit of coloured balls and fins. The elegant trick is that the compound unit is suspended closer to the central

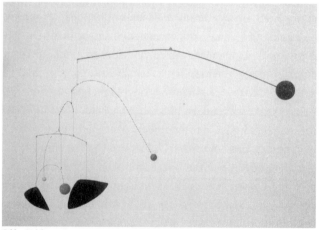

Calder, *Mobile*, c.1938

axis than the biggest ball, while each of the suspended sub-units are mutually inter-balanced in such a way that they can twist on their axes without affecting the overall balance. It does not look that difficult. The mobile depends on the asymmetrical suspension of each successive sub-unit in the most delicate and critical manner. The whole and the parts are susceptible to the slightest stirring of air, gliding across curved space in a silent ballet. Sculpture can now move. The look of elegant inevitably is hard-won. Like other great abstract art, Calder's mobiles are miracles of natural engineering without imitating nature.

Over the course of little more than half a century there are serial attempts to tell us that art is not what we thought it is. We have repeatedly been asked to do the unexpected, with inevitable resistance when the questions have first been poised. Provocation has become a matter of both conviction and posture. To be derided by the establishment was becoming the norm – indeed it was almost a prerequisite if one wanted to be regarded as truly creative.

9

SOMETHING
DIFFERENT

'The End of Painting', *October*, 1981, by Douglas Crimp, American art historian:

'From today painting is dead': it is now nearly a century and a half since Paul Delaroche is said to have pronounced that sentence in the face of the overwhelming evidence of Daguerre's invention [of photography]. But even though that death warrant has been periodically reissued throughout the era of modernism, no one seems to have been entirely willing to execute it; life on death row lingered to longevity. But during the 1960s, painting's terminal condition finally seemed impossible to ignore. The symptoms were everywhere: in the work of the painters themselves, each of whom seemed to be reiterating [Ad] Reinhardt's claim that he was 'just making the last paintings [his black canvases] which anyone can make,' or to allow their paintings to be contaminated with such alien forces as photographic images; in minimal sculpture, which provided a definitive rupture with painting's unavoidable ties to a centuries-old idealism; in all those other mediums to which artists turned as they, one after the other, abandoned painting. The dimension that had always resisted even painting's most dazzling feats of illusionism – time – now became the arena in which artists staged their activities as they embraced film, video, and performance.

And, after waiting out the entire era of modernism,
photography reappeared, finally to claim its inheritance.

We are standing on the edge of the shifting sands of Postmodernism, a politicised philosophy that has coloured most non-scientific disciplines since the second half of the twentieth century. Postmodernism is protean, diverse, non-unified, non-programmatic and often obscure. Postmodernists often emphasise language as a kind of game that resists fixed meanings and definitive content. It is easier to say what Postmodernists are not than to define what they set out to do. They often espouse resistance to traditional Western Enlightenment rationalism, which is seen as culminating in modernism and its aesthetic of 'Art'. They reject great explanatory narratives. They undertake the political 'deconstruction' of art and the intentions of the artists, analysing works as constructions of the social imperatives that brought them into being.

A good deal of the theorising in the visual arts has been driven by the transformation of art teaching into an academic subject. Art colleges have been invaded by art history, aesthetics and 'theory'. Artists have learnt to write prose that is often as impenetrable as that of professional writers on art. There is a lot of name-dropping – Theodor Adorno, Jürgen Habermas, Walter Benjamin, Michel Foucault, Jacques Derrida, Edward Said, Fredric Jameson and Douglas Crimp (who prematurely hailed 'the end of painting' in 1981).

Postmodern art is marked by the ironic glorification of the popular and a dedication to social comment rather than

the 'aesthetic', often using words as images. We encounter a great deal of art about art. Visual quotations and pastiche abound. There are many visual jokes, big in size and often small in meaning. We are confronted by an astonishing range of genres, ranging from the thought-based practice of Conceptual art (which might not result in any physical art work), through the ephemeral medium of performance, to elaborate installations of diverse objects.

We are better advised to look at what actually happened during this period than to get caught up in the paradox of a term that repudiates definition. In traversing these quicksands, we do well to remember that Postmodernism is a concept used by critics and art historians rather than a programme to which artists signed up. In looking at the visual products we are best served by thinking of the participants as 'stagers of visual events' rather than makers of art works in the normal sense. In this respect, Duchamp got there first. Publicity and public exposure become the key to a successful career and we see the rise of artists as provocative celebrities, to such an extent that the actual works of art can sometimes seem secondary. We should also realise that the job of embracing all genres in this busy period is impossible here.

One conspicuous change is the arrival of women artists as leaders in the re-definition of art. Five of the works illus-trated here are by women. The rise of the woman artist is a conspicuous part of the increasing prominence of women in a series of technical professions previously regarded as the natural territories for men. This welcome development has been accompanied by the reinstatement of notable

women artists from the past, such as Artemisia Gentileschi, the Baroque artist whose narrative paintings of women *in extremis* provide different kinds of insight from those of her male relatives and colleagues.

The ironic annexing of popular imagery played a major role in moving beyond abstraction. This move is exemplified in Richard Hamilton's *Just what is it that makes today's homes so different, so appealing?*, from 1956. Hamilton is not depicting popular images but is pasting together items

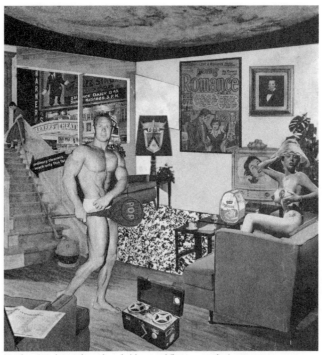

Hamilton, *Just what is it that makes today's homes so different, so appealing?*, 1956

removed and cut out from magazines and advertisements. The manufactured 'couple' occupying the home of today consists of a pin-up wearing a lampshade and a posed muscleman, who partly covers his diminutive costume with a POP lolly. Behind him a woman demonstrates the extended reach of the latest vacuum cleaner. There is tinned ham on the table, while the couple 'ham it up' in the hope of the 'True Romance' of the poster on the wall. It seems that their home is just over the road from a cinema showing Al Jolson's maudlin *The Jazz Singer*.

Hamilton's collage featured in the seminal exhibition *This is Tomorrow* organised by the Independent Group at the Whitechapel Art Gallery in London. Even earlier, Eduardo Paolozzi had exhibited his 'Bunk!' series in the first Independent Group exhibition in 1952, which included his early collage *I was a Rich Man's Plaything* (1947). The dominant item in the collage is the front cover of 'Intimate Confessions' in which a laughing 'ex-mistress', who is drawn displaying a lot of stockinged leg, is jokingly shot by a pistol that goes 'POP!'. The accumulative way in which Paolozzi and Hamilton use an iconography of 'signs' has much in common with medieval and Renaissance images. It was Hamilton who provided the actual definition of what the modern iconography was about; 'Pop Art is: popular, transient, expendable, low-cost, mass-produced, young, witty, sexy, gimmicky, glamorous, and Big Business'.

The standard-bearer for Pop in the USA was Andy Warhol, who began his career in advertising as a graphic artist. His first solo show as a 'Pop artist' was held in the Stable Gallery in New York in November 1962. It featured

works that involved what became one of his trademarks, the serial repetition of images from popular culture including the *Marilyn Diptych, 100 [Campbell's] Soup Cans, 100 Coke Bottles,* and *100 Dollar Bills.*

The *Marilyn Diptych*, one of a series of works generated in the aftermath of the actress's tragic death, is based on a publicity photograph issued for the film *Niagara* in 1953. The 25 images on the left, skilfully created with an innovative technique of screen-printing and painting, are debased as low-grade reproductions that are then 'carelessly' tinted with four garish colours. On the right 25 monochrome images are crudely printed. The dead Marilyn smiles and flutters her eyelids, as she had been required to do many thousands of times. The effect is more psychotic than joyous.

Warhol celebrated the democracy of mass culture – the way that a Coke bottle used by the president is the same as that available to a street 'bum' – but tragedy lurks. His series on Marilyn Monroe, Jackie Kennedy, the electric chair and a car crash bring death into the foreground. Warhol, whose background, it is worth remembering, was Polish Catholic, with its array of religious icons, 'iconised' the bright and dark icons of popular culture, human and material. The religion of his time was rampant consumerism in which he participated with feverish delight. The gods of the glittery modern religion were propitiated by a succession of human sacrifices, transformed by Warhol into mass-produced saints. Their attributes were cans of soup and bottles of pop.

Warhol became the self-defining star of his own public life, surrounded in his 'Factory' by an entourage

specialising in trendy weirdness. He was a virtuoso in a wide range of media and his films, always provocative, often self-parodying and frequently pornographic, brilliantly challenging how the medium could be used. He was hugely successful, not least in financial terms. In 1968 he was shot by a woman on the fringe of his circle, and barely survived. He lived in a theatre of extremes.

American Pop was big, brash and noisy. This is very much the case with the leading sculptor, Claes Oldenburg, the Bernini of consumerism. He was active as a notable performance artist and made his public breakthrough with soft sculptures, in which familiar objects, such as a hamburger or hot dog, are wittily rendered on enlarged scales in loosely stuffed textiles. They rely upon multiple ironies: of the solid made squishy; of the familiar rendered alien; of representations that highlight their odd means of

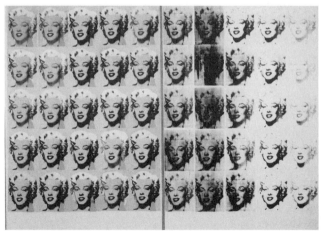

Warhol, *Marilyn Diptych*, 1962

representation; of objects that are not much like the real thing but remain instantly recognisable.

Oldenburg's stock-in-trade from the 1970s onwards became huge public versions of everyday objects, simplified and brightly coloured, as the icons of our modern lives. The Oldenburg piece shown here, the *Dropped Cone*, undertaken with his Dutch partner Coosje van Bruggen and installed in Cologne, dates from 2001, the very end of our period. Teetering on the corner of a shiny shopping centre is a vast ice-cream cone, dropped as it were by a massive passing angel. Its abundant vanilla goo is beginning to dribble over the windows. It's a big joke, but is one that evokes some suggestive meanings. The artists have indicated that they intended to echo the gothic spires of Cologne, most notably those of the Cathedral. Van Bruggen stressed that their unstable spire serves as a 'sign of transience' – much in the manner of the 'vanities' signalled by Dutch seventeenth-century still lifes. She also described the cone as a 'cornucopia of consumerism'. As such, it has a certain poignancy. I recall my own dismay as a child when my keenly

Oldenburg and van Bruggen, *Dropped Cone*, 1998–2001

Kruger, *Untitled (I shop therefore I am)*, 1987

anticipated treat drops on the ground with a splodge – the wrong way up as always.

Consumerism is presented in a politically sharper and more aggressive guise by Barbara Kruger's *Untitled (I shop therefore I am)*. Her typographical assertion starkly subverts *Cogito ergo sum* (I think therefore I am), the famous declaration by the French seventeenth-century philosopher, René Descartes. In its philosophical context, *cogito* certified individual existence and indeed provided the basis for Descartes' system of knowledge. Kruger translates it into a shallow assertion of identity – probably a female identity – through the act of shopping. Reticence is not the name of

her game. She characteristically exploits **futura bold italic** in white against a strong red background, imposed on a grainy black-and-white print of a shopper's hand. In a more overtly feminist vein, a split-screen image of a beautiful woman's face, in positive on the left and in negative on the right, declares **Your body/is a battleground.** She enlarged a number of her images on to billboards, shouting in the streets alongside advertisements.

Like Warhol, Kruger had worked as a commercial designer and effectively inverted the meaning of the techniques she used: 'although my art work was heavily informed by my design work on a formal and visual level, as regards meaning and content the two practices parted ways'. The dividing of ways lies in the context – 'Art' rather than advertising (though her billboards confound the distinction) – and in the social bluntness of the content. She has stated that she is engaging in 'issues of power and

Holzer, *Xenon for Venice (In the Night When No Women Go About And)*, 1999

sexuality and money and life and death and power'. She is undertaking this massive job by importing simple and memorable means from commercial art.

Kruger is one of a redoubtable group of socially minded female artists, mainly American, who have made bold topographical interventions in public spaces. Jenny Holzer's signature medium, LEDs (light-emitting diodes), also comes from the commercial world, though she herself came from an art background. She has typically used LEDs for the projection of declamatory texts on large public buildings. The texts themselves tend to be more literary than Kruger's, more ambiguously open and incomplete, like fragments from a passing conversation. Her *Xenon for Venice (In the night when no women go about and)*, was staged in the city where she had earlier triumphed at the Biennale. The Xenon of the title is the noble gas used in arc lamps and lasers, and in her projections. The truncated sentence sets in train a series of thoughts and allows completion in whatever way we will. For me, the text evokes the sinister night-time atmosphere of narrow Venetian alleys, which are as likely to terminate in a wall or a canal as they are to open onto a spacious piazza. Her text has just such an abrupt termination.

Broadly speaking, Kruger and Holzer can be seen as making Conceptual art, which was described by Sol LeWitt thus: 'the idea or concept is the most important aspect of the work. When an artist uses a conceptual form of art, it means that all of the planning and decisions are made beforehand'. It may be the case that there is no fixed, material output, ostensibly undermining art as commercial commodity – although other financial strategies were developed to keep

the wolf from the Conceptual artist's door. LeWitt, whose own work involved minimal geometries, stressed that the execution of the idea might be 'a perfunctory affair'. Almost inevitably, the Conceptual art that has endured is that which translates the idea into an appropriate medium.

It may be that women artists came to the forefront in exploring alternative media because traditional painting and sculpture, particularly on a large scale, were too heavily identified with big blokes. A number of female artists identified their own bodies as subjects ripe for critical exploration, in a manner very different from traditional painting. Performance, some of which was very edgy, played a crucial role. Yoko Ono and Marina Abramovic were especially prominent on the international stage. Ono's *Cut Piece*, first performed in Kyoto in 1964, induces an uneasy sense of implicit sexual violence, undiminished by the passing of half a century. Based in New York, Ono became a leading artist in the worldwide Fluxus movement, which embraced a series of experimental art forms, including the music of John Cage and the video/television art of the Korean, Nam June Paik. Fluxus was a natural heir to the anarchic provocations of Duchamp.

A 1965 film of Yoko Ono's *Cut Piece* shows her kneeling impassively on the boards of the platform in the Carnegie Recital Hall in New York. She is dressed in black and a shiny pair of sharp scissors lies in front of her. Members of the audience, women and men, one by one, walk silently up to her, grasping the scissors and snipping at various parts of her outfit, progressively reducing it to tatters. Ono stares unwaveringly to the front. Only her blinking signals any kind

of reaction. Inevitably, the decimation of her dress threatens to expose her body, and her increasingly visible bra is snipped by an unpleasantly persistent male cutter, to whom Ono does react, albeit passingly. The piece finishes with her cradling what remains of her underwear over her breasts. There is no overt nudity, but the emotional charge is incredibly high. Her

Ono, *Cut Piece*, 1964

passivity in the face of unpredictable cutting is unsettling. The incisive steel blades repeatedly threaten her flesh. Like all major art, *Cut Piece* has the ability to get under our skin, insinuating itself in our memory and affecting our perceptions. It revises our notions of what we think art can do.

The greatest and most infuriating of the shaman-performers was Joseph Beuys, also active in Fluxus shows. A consummate poseur who invented a series of life myths, he served as the Pied Piper to a generation of artists in the late twentieth century. The central myth involves his plane crash when serving as a Luftwaffe gunner, followed by his rescue from near death in snowy Crimea by roving Tartars. Beuys tells unreliably how

> The Tartars found me days later. I remember voices saying 'Voda' (Water), then the felt of their tents, and the dense pungent smell of cheese, fat and milk. They covered my body in fat to help it regenerate warmth, and wrapped it in felt as an insulator to keep warmth in.

Fat and felt, as the elements of a kind of organic battery, became a recurrent part of his personal iconography, as he shaped his own life into a provocative artefact in which fiction vies with fact. He generated his universal concept of 'social sculpture', in which a series of internationally staged events were designed to create a revolution in which everyone can annex the transformative power of art to change the world. Rabidly anti-capitalist and scathing about the mechanistic rationality of modern science, Beuys wanted to divert the psyche of the modern world. A series of blackboards, produced during rambling lectures-cum-happenings, exploited words, symbols and expressively scratchy drawings in order to proselytise his radical ideals, including a commitment to the natural environment in the face of human destruction.

In 1974 he arrived in New York from Germany. At the airport, he was wrapped in his beloved felt and placed in an ambulance, which wailed through the cavernous streets to the gallery on West Broadway run by the adventurous German art publisher and gallerist, René Block. There, enveloped in a great felt blanket and brandishing a shepherd's crook, he embarked on a three-day residence with a coyote. Beuys semi-orchestrated a tense emotional choreography, in which the small native wolf restricted its nervy hostility to the artist's blanket, crook and gloves. Piles

Beuys, *I Like America and America Likes Me*, 1974

of the *Wall Street Journal* were abandoned to the coyote's innumerate instincts. The America of his title, *I like America and America Likes Me*, is the America of the coyote, and through this the America of the wild, and the America of the indigenous 'Indians'. His America is not the commercial America of New York. Of course he was hoping that the New York art world would 'like' him and ensure that his visit exercised a promotional impact – as indeed it did. He returned to the airport in the ambulance, having only set foot on the boards of the gallery floor.

Beuys signals another conspicuous feature of art in the Postmodern era, namely the increasing intrusion of autobiography. The most remorseless exploiter of personal trauma is Tracey Emin, one of the most prominent artists in the group of so-called YBAs (Young British Artists), many of

Emin, *My Bed*, 1998

whom produce works that operate effectively to attract media attention while leaving the spectator little room for reflection. They are making 'fast art', which shares much in common with fast food. Emin gives us much more than this.

Emin's notorious *My Bed* has appeared in various guises. Its debut was at the 'alternative' Sagacho Exhibit Space in Tokyo in 1989, where it was accompanied by a hanging rope noose, and wooden coffin with two suitcases bound in chains. It came to prominent media attention in 1999 in the Turner Prize show in the Tate Gallery, where it attracted a good deal of noisy attention. It was plastered on billboards in London in 2004, and made retrospective reappearances in 2012, by which time its relationship with her life was more archaeological than current. The main version is in the collection of Charles Saatchi, the advertising magnate

whose extensive collecting fuelled the rise of the YBAs. The shock of *My Bed* is not so much that she is exhibiting a 'readymade', or even a 'ready un-made' but rather the visceral nature of the accompanying attributes. On the blue carpet are scattered chaotic shards of a life that seems near disintegration – vodka bottles, fags, grubby slippers, Polaroid portraits, a fluffy toy dog, condoms (used and unused), stained underwear. Traces of body fluids are much in evidence. The rumpled bed speaks more of turmoil than repose. We recall that a sinister noose and coffin accompanied the Tokyo version.

The idea, of course, is that we can read a desperate phase of the artist's life from its eloquent remains, much like a detective reading a crime scene. This is indeed what we do. We see *her* bed and how *she* passed a torrid period in it, boozing and fornicating. However, in reality it is a highly contrived evocation of a crucial point in a life which, like that of Beuys, is presented in a way that blends reality and myth. The bed linen, for all its rumpling, shows little forensic evidence of having been pressed by a warm body and weighty head over a prolonged period. The graining pattern of the basic bed-base, in its Japanese manifestation, is different from that in the Saatchi Gallery. I wonder if the bodily fluids are real or pigmentary. Each time it is re-shown, it has to be systematically re-installed, and Emin insists on controlling this herself. There is no problem with all of this. It is a highly communicative visual event not a factual documentary.

An event, as in physics, is something inscribing itself at a moment or across successive moments seized from the

space-time continuum. If anyone had said that a garden shed full of 'stuff' could speak of a cosmological event, we would have had every reason to be sceptical. But this is just what Cornelia Parker achieved in 1991 with *Cold Dark Matter: An Exploded View*. Parker is another artist whose

Parker, *Cold Dark Matter: an Exploded View*, 1991

practice can be embraced, at least in part, by the term Conceptual art, although her execution is never 'perfunctory', to use LeWitt's word. On one occasion she made microphotographs of the furrows in Hitler's record of the 'Nutcracker Suite'. We imagine Tchaikovsky's sugary tune in Hitler's ears at a particular moment – the paradox of sweet music for an evil listener. She has created a kind of 'relic'.

In *Cold Dark Matter*, an unremarkable garden shed, stuffed with clutter, was exhibited in an empty gallery. It was then taken into a field where it was blown apart by the army in a cascade of fractured planks and shattered possessions – a deformed plastic dinosaur, a ruptured boot, a mangled hot-water bottle, a brass euphonium wrenched out of tune … Gathered up, the dispersed debris was reassembled in the gallery as a constellation of fragments, hung on wires. Illuminated internally by bright light, its dark shadows are projected across space onto the roof, walls and floor.

In cosmology, CDM (cold dark matter) has been seen as accounting (invisibly) for up to 80 per cent of matter in the universe. Small conglomerations are described as collapsing gravitationally on themselves and aggregating to form progressively larger objects. Parker is not illustrating the science but working with the poetry of the name and the sublime power of the idea. We cannot tell if her frozen array is undergoing endless dispersion or coming back together. It orbits around opposites: gathering and dispersal, expansion and contraction, explosion and implosion, inhaling and exhaling, falling and suspension, transformation and stasis, peace and violence, making and breaking, playful and sinister. In the array as seen, these alternative states exist

as simultaneous possibilities – unless we can intervene to measure what is happening. In cosmology and physics we are often in the position of being able to see only the shadows, from which we strive to reconstruct the elusive reality. We are back in the territory of Plato's shadows.

Time-based media, in which things are moving, played a crucial role in the second half of the century. The advent of portable and cheaper video cameras encouraged artists to record films, often without narratives, to be shown in galleries. Initially they were displayed like moving paintings, and were later used to create complete installations. The low quality of much early video – jumpy and flickering on television screens – was often exploited for its suggestiveness. The acknowledged master of video art at the highest level of visual quality and sophistication is Bill Viola, whose practice has been in consistent dialogue with historic art. The eloquent use of expression and gesture in traditional history painting helps him to understand how to 'connect with people'. *Emergence* was one of the fruits of his residence at the Getty Research Institute in Los Angeles in 1988, although it was only realised in 2002.

Viola's source of inspiration is a fresco of the *Pietà with the Virgin and St John* in Empoli by Masolino, who collaborated with Masaccio. In glorious detail and aching slow motion, we watch a naked man, pale as white marble and seemingly unconscious, ascending inch by inch from an altar-cum-tomb. A cascade of pure water overflows as he seeps into the air. Two mournful women, on either side of the tomb rise in profile to support his body as it limply slides into their arms. They gently lay his de-tombed body

Viola, *Emergence*, 2002

on the ground, where he is covered with a white shroud. His mourners tenderly cradle his head and arms.

Viola's tableau is not a narrative from the life of Christ. Rather it looks to an ancient vocabulary of embodied emotion and the restrained portrayal of lucid space to portray the emergence of an unknown man, maybe drowned, from a watery grave. The man has risen through some unseen volition, not because the women have lifted him. It is a narrative for which we do not need a literal story in order to be emotionally moved.

In traversing some fifty years, we have encountered collage, screen-printing, photographic imagery, fibre-reinforced plastic, xenon light, filmed performance, personal and cosmic detritus, and a projected video. We could also have included computer art. It seems that Crimp might be right in his declaration of the 'end of painting'. Looking for redefinitions of art and its relationship to the spectator has moved us away from traditional media and from time-honoured ends. However, painting, like the novel, undoubtedly lives on. Just when we think it has all been done before, someone makes paint on surfaces do something fresh and compelling. To finish, I will look at two examples: one of an artist who uses paint and materials in a new kind of way, and the other whose chosen medium is essentially no different from that of Titian or Velásquez.

The former is the German artist Anselm Kiefer, who creates huge multimedia paintings and massive sculptures that speak of how sinister past events infiltrate the present.

Kiefer, *Nigredo*, 1984

Some of his paintings embed such diverse materials – straw, paper, lead, broken glass, wood, plants, wire, ash, earth – that they almost become reliefs. They often incorporate roughly painted words, which underlines their literary character. His *Nigredo*, over 18 feet wide, has a plunging perspective that plays off against an abrasive surface in a way that scours our senses. We see a deeply furrowed land bristling with burnt stubble, an agricultural battlefield that stands for the real thing. On a photograph printed on to the canvas, Kiefer has built up deeply encrusted layers of various kinds of paint – oil, acrylic, emulsion and shellac – with embedded straw. Jagged fragments of paper act as a hostile barrier of dark boulders. Like the battlefields over which his native Germany fought in two world wars, the land has been laid to waste.

The title, scribbled boldly on the sky, alludes to the ancient mysteries of alchemy. The state of utter blackness or *nigredo* was where alchemical processes had to begin. *Nigredo* arose from putrefaction, decay, decomposition, disintegration and incineration. It was the initial state of 'prime matter' to which all substances needed to be reduced before their fiery alchemical journey into higher realms of distilled existence. Kiefer has been much concerned with great historical mythologies and metaphysics, which are at once repellent and inspiring. It may be that the ashen glimmer of the fields and sky promises that we can at least glimpse the beginnings of the alchemical ascent into the realms of illumination.

My other example simply involves painting. Even the subject is traditional: a seventeenth-century pope. The

pope in question is Innocent X, painted in Rome around 1650 by Velásquez in notably frank manner. The pope sits on a gilded throne, and is dressed in a red silk mozzetta (cape), lace rochet, and white silk cassock. He is viewed at an angle from his right, in the manner established by the

Bacon, *Study after Velázquez's Portrait of Pope Innocent X*, 1953

great earlier portraits by Raphael and Titian. Francis Bacon had undertaken a series of popes in 1948–9, some of which merged with a likeness of David Sylvester, the writer on art. The scream gradually emerged as the dominant expressive motif, drawing upon Bacon's recurrent fascination with the screaming head in Poussin's *Massacre of the Innocents* and with a still of the shrieking nanny with a bleeding eye and fractured glasses from Eisenstein's magnificent film, *Battleship Potemkin*. Bacon aspired 'to be able to paint the mouth like Monet painted a sunset' – by hard observation and painterly experiment. This highlights what we noted when looking at van Gogh and Munch; that is to say, the most violently expressive art requires a great deal of conscious deliberation.

Bacon described painting as 'the pattern of one's own nervous system being projected on the canvas'. This projection very often involves a perspectival frame of painted lines within which the figure plays out its nervous motions. The throne of Bacon's pope has been extended into a golden cage with curved bars. The screaming pope, so freely and thinly painted as to be dematerialised, is inundated by a vertical shower of veiling brushstrokes that fan out below his lace rochet in a violent centrifugal array. The great pope, a leading patron of Bernini, appears trapped within his massive spiritual and public role to such an extent that he cannot be truly seen – but we can still hear his protests. The feeling of being trapped by how others see us is an experience that we can relate to.

Bacon's painting dates from well before the declaration of the 'end of painting', but his life was to endure for almost

another 40 years, during which he continued to paint with considerable power. Kiefer is still painting and sculpting with undiminished creative vigour, as are younger artists of note. Both Kiefer and Bacon, like Viola, have engaged deeply with the art of the past, and have succeeded in creating something urgently individual. Painting lives! – within the bewildering and thrilling range of possibilities open to artists today.

In the last half of the century we have passed from a series of movements each of which claimed special access to the true secret of art (or even of non-art) into an era of plural values, often accompanied by irony, cynicism and self-conscious alienation. Art has become locked into multiculturalism and transmission by global media, serving as its own kind of advertising. A big name for an artist has become a form of commercial currency. In this context, it would be easy to write off recent art as an ephemeral manifestation of the entertainment industry. However, great and sincere artists, of the kind we have encountered, show that they can simultaneously exploit and transcend the immediate circumstances in which they have to operate – as great artists have always done.

10
CONCLUSION

I hope it has become clear that works of art are immersed in the history from which they emerged. In some cases this shaping is direct and obvious, as with Rubens's *Horrors of War* and Picasso's *Guernica*; in others, such as Titian's *Martyrdom of St Lawrence* and Mondrian's abstract canvases, the shaping is more subtle and complex, often relating to the broader position of art as it developed within various societies. Notions of art and artists changed radically in conjunction with huge transformations in the functions of art and the ways in which it was viewed.

It is evident that the understanding of form, content, function and viewing is dependent on our analysis of the cultural context. In that sense, art obviously has a history and its history informs our experience of viewing art. This raises the question: is there something in art that transcends this historical dimension? If we regard art as the 'deposit of a social relationship', to use a phrase of Michael Baxandall's, is that all it is? Is art devoid of absolute value outside the context of its making?

Even on its own terms, this 'deposit' view of art is too passive, because art has clearly been an active shaper of political and cultural values. The study of history needs art history. However, this contextual view fails to satisfy our enduring sense that the creations of the past still manage

to communicate something today, whether via content or form or both. Is that something 'aesthetic value'?

Aestheticians from the late eighteenth century onwards have striven without apparent consensus to define a 'super-essence' of art applicable across all periods and cultures. I was going to argue that no such definition is possible – that we are actually dealing with a 'fuzzy category' in which we recognise associated values without there being a fixed set of core characteristics that are *necessarily* always present. This accommodates the observation that not everything is possible at every time, as well as recognising something we can effectively call art even when its creators had no notion of art or entertained a notion very different from our own.

However, I would like to approach the question from a more radical point of view. Enquiries into the essence of what art is generally start with the assumption that there is such an essence. What if we abandon this assumption, saying that it is wholly unnecessary? This puts the boot on the other foot. I do not see any reason why an ancient *kouros*, a Pollock drip painting, a Jenny Holzer projection and a portrait of Queen Elizabeth II by an academic painter should necessarily have anything essential in common, beyond the fact that they are man-made visual things that aspire to engage our sustained attention and carry mean-ings. They exist in a continuous spectrum of such visual products, including the advertisements admired by Pop artists, and operate at the more complex and multilayered end of the spectrum. It is a matter of institutional evolu-tion of the academies and art galleries that the diversely functioning things we categorise as art have come to be

accommodated together, physically and conceptually. It is this accommodation that misleads us into thinking that Pollock and the portraitist are in the same kind of aesthetic business. Indeed, I would go so far as to say aesthetics is a *historical* study of successive attempts to define the essence of art. We should have grown out of it by now. Duchamp should have taught us this.

Does this leave us with the social explanation? Yes and no. Yes, in as much as every work is of its time and place, as we have seen. No, in as much as every work is an expression of basic human impulses, above all the impulse to communicate through the making of visual things. It is my conviction (perhaps as someone trained as a biologist) that humans have not essentially changed over the relatively brief course of recorded human history. Our loves, our pleasures, our dislikes, our fears, individually and in broader social settings, are much the same now as in ancient Greece or in Palaeolithic times. These basic human traits have to be expressed in concrete ways and in the specific contexts that are available in specific places and at specific times. There is no alternative to this material and social embedding – just as we cannot say how pleased we are to be warm without a specific material and subjective context for the understanding of that statement. Warmth is not something we can define absolutely and autonomously. Warmth as an experience exists in a shared communicative framework in which we can speak and someone can listen. Art speaks to us in this contextual manner. One of the powers of the visual things we have learnt to call art is that it can make us feel the horrible heat of Titian's painted flames, but they

only carry their full meaning in the picture of St Lawrence being grilled. We can see that something agonising is happening in Titian's great canvas, but we understand more richly when we can inhabit the human and spiritual context within which excessive heat assumes meaning.

Art is *in* history, and cannot come into existence outside it. Yet it can still speak to us in profoundly human terms.

LIST OF ILLUSTRATIONS

Chapter 1

Page 8
Marble statue of a Kouros, c. 590–80 BC. Fletcher Fund,
1932, Metropolitan Museum, New York
www.metmuseum.org

Page 8
Kouros, marble, *c.* 540 BC, Athens, National
Archeological Museum

Page 8
Riace Warrior A, (bronze), Greek, (5th century BC) /
Museo Archeologico Nazionale, Reggio de Calabria, Italy /
Alinari / Bridgeman Images

Page 11
After Praxiteles, *Venus of Knidos*, marble *c.* 350 BC,
München, Staatliche Antikensammlungen und Glyptothek

Page 12
Phidias, *Sculpture of the left side of the east pediment of the
Parthenon*, marble, *c.* 445 BC. London, British Museum ©
The Trustees of the British Museum

Page 13
Agesander, *Athenedoros, and Polydoros, Death of Laocoön and his Sons*, marble, *c.* 50 BC, Vatican City, Vatican Museums and Galleries

Page 14
Mosaic of the Battle of Alexander against Darius, *c.* 100 BC, Naples, Museo Archeologico Nazionale

Page 15
Head of an Old Man, marble, *c.* 50 BC, Vatican City, Vatican Museums and Galleries

Page 17
Wall fresco depicting garden and birds, House of the Golden Bracelet, Pompeii / De Agostini Picture Library / L. Pedicini / Bridgeman Images

Chapter 2

Page 22
The Good Shepherd, mosaic, *c.* 425, Ravenna, Oratorio di Galla Placidia

Page 24
Madonna and Child (the 'Icon of Vladimir'), tempera and gold leaf on panel, *c.* 1130, Moscow, The State Tretyakov Gallery ©akg-images / RIA Nowosti

Page 26
The Book of Kells. Chi Rho monogram. Folio 34r.
8th century, Dublin, Trinity College Library. Photo ©
Tarker / Bridgeman Images

Page 27
Reliquary Statue of Sainte Foy, gold, precious stones and
wood, *c.* 900, Abbey-Church of Conques © akg-images /
Erich Lessing

Page 29
*Central West Portal (the 'Royal Portal') of Chartres
Cathedral: Christ with the Symbols of the Evangelists, the
Elders of the Apocalypse, the Disciples, and the Kings of
Queens*, limestone, *c.* 1225–40

Page 30
Virgin and Child, c. 1345, marble with traces of gilding,
Fletcher Fund, 1924, Metropolitan Museum, New York
www.metmuseum.org

Page 31
Fight for the Soul of the Deceased from The Rohan Hours,
paint, ink and gold, 1430, Paris, Bibliothèque Nationale,
© akg-images

Page 33
Tomb of Richard de Beauchamp, 13th Earl of Warwick,
brass and stone, 1448–53, Warwick, Church of St Mary

Page 35
The Unicorn Fights off the Hunters, tapestry, *c.* 1500,
Metropolitan Museum, New York www.metmuseum.org

Chapter 3

Page 41
Giotto, *Lamentation of Christ*, fresco, *c.* 1303–6, Padua,
Cappella degli Scrovegni, © akg-images / Cameraphoto

Page 43
Ambrogio Lorenzetti, *The City under Good Government*,
fresco, 1338–9, Siena, Palazzo Pubblico

Page 44
Masaccio, *Trinity*, fresco, *c.* 1526–7, Florence, Santa Maria
Novella © akg-images / Erich Lessing

Page 46
Donatello, *Gattamelata (Equestrian Monument to Erasmo
da Narni)* bronze, 1443–53, Padua, Piazza del Santo © akg-
images / De Agostini Picture Library /
A. Vergani

Page 48
Jan van Eyck, *The Arnolfini Wedding*, oil painting on panel,
1434, © The National Gallery, London / akg-images

Page 49
Bellini, *St Francis*, oil painting on panel, *c.* 1478,
New York, Frick Collection

Page 52
Leonardo da Vinci, *Portrait of Lisa del Giocondo
(the 'Mona Lisa')* oil painting on panel, 1503–16,
Paris, Louvre

Page 54
Michelangelo, *David*, Carrara marble, 1501–4,
Florence, Accademia

Page 56
Albrecht Dürer, *Madonna of the Rosary,* oil painting on
panel, 1506, Prague, National Gallery

Page 59
Giorgione, *La Tempesta*, oil painting on canvas, *c.* 1506,
Venice, Accademia

Page 60
Titian, *Martyrdom of St Lawrence*, oil painting on canvas,
1559, Venice, Church of I Gesuiti

Page 62
Pieter Bruegel, *Winter (Hunters in the Snow),* oil painting
on panel, 1565, Vienna, Kunsthistoriches Museum

Chapter 4

Page 67
Nicolas Poussin, *The Israelites Gathering Manna in the Desert,* oil on canvas, 1637–9, Paris, Musée du Louvre ©akg-images / Erich Lessing

Page 71
Michelangelo Merisi da Caravaggio, *Crucifixion of St Peter,* oil on canvas, 1600–1, Rome, S Maria del Popolo, Cerasi Chapel

Page 73
Gian Lorenzo Bernini, *Ecstasy of St Theresa,* marble and gilded bronze, *c.* 1647–52, Rome, S Maria della Vittoria, Cornaro Chapel

Page 75
Peter Paul Rubens (1577–1640), *The Consequence of War,* 1637–8 (oil on canvas) / Palazzo Pitti, Florence, Italy / Bridgeman Images

Page 76
Sir Anthony Van Dyck, *King Charles I at the Hunt,* oil on canvas, 1638, Paris, Musée du Louvre ©akg-images / Erich Lessing

Page 79
Diego Velásquez, *Las Meninas (The Maids of Honour),* oil on canvas, 1656, Madrid, Museo del Prado

Page 80
Rembrandt van Rijn, *Anatomy Lesson of Dr Tulp*, oil on canvas, 1632, The Hague, Maritshuis

Page 83
Jan Vermeer, *The Art of Painting*, oil on canvas, *c.* 1666–8, Vienna, Kunsthistorisches Museum

Page 84
Jacob van Ruisdael, *Windmill at Wijk bij Duurstede*, oil on canvas, *c.* 1670, Amsterdam, Rijksmuseum

Chapter 5

Page 89
Jean Antoine Watteau (1684–1721), *The Gersaint Shop Sign*, 1721 (oil on canvas) / Schloss Charlottenburg, Berlin, Germany / Bridgeman Images

Page 92
Antonio Canaletto, *Square of S Marco, Venice*, oil on canvas, *c.* 1742–4, Washington, National Gallery of Art ©Universal History Archive/UIG via Getty images

Page 93
William Hogarth, *The Tête à Tête, Marriage à la Mode no. 2*, oil on canvas, *c.* 1743, London, National Gallery

Page 96
François Boucher, *The Rape of Europa*, oil on canvas,
c. 1732–4, London, Wallace Collection © akg-images /
De Agostini Picture Library

Page 98
Jean-Baptiste-Siméon Chardin, *The Young Schoolmistress,*
oil on canvas, *c.* 1735–6, © The National Gallery, London /
akg-images

Page 100
Jean-Antoine Houdon, *Voltaire,* marble, 1781,
St Petersburg, Hermitage

Page 101
Sir Joshua Reynolds, *Sir David Garrick between Comedy
and Tragedy*, oil on canvas, 1760–1, Waddesdon, National
Trust, Rothschild Collection

Page 103
Jacques-Louis David, *Oath of the Horatii,* oil on canvas,
1784, Paris, Musée du Louvre

Chapter 6

Page 108
Francisco Goya, *Third of May 1808*, oil on canvas, 1814,
Madrid, Museo del Prado

Page 111
Antonio Canova (1757–1822), *Napoleon as Mars the Peacemaker* (marble), 1803–6, Apsley House, The Wellington Museum, London, UK / © English Heritage Photo Library / Bridgeman Images

Page 113
Jean Auguste Dominique Ingres, (1780–1867), *Odalisque with a Slave*, 1839–40 (oil on canvas) / Fogg Art Museum, Harvard Art Museums, USA / Bequest of Grenville L. Winthrop / Bridgeman Images

Page 116
Eugène Delacroix, *Death of Sardanapalus,* oil on canvas, 1827, Paris, Musée du Louvre

Page 119
Philip Otto Runge, *Morning,* oil on canvas, 1808, Hamburg, Kunsthalle

Page 121
Caspar David Friedrich, *Wanderer Above the Sea of Fog,* oil on canvas, 1818, Hamburg, Kunsthalle

Page 123
Joseph William Mallord Turner, *The Fighting Temeraire Tugged to her Last Berth to Be Broken Up*, 1838, London, National Gallery

Page 124
John Constable, *Landscape: Noon ('The Haywain')*,
oil on canvas, 1821, London, National Gallery

Page 128
Frederick Edwin Church, *Niagara Falls from the American
Side*, oil on canvas, 1867, Edinburgh, National Gallery of
Scotland

Chapter 7

Page 133
Gustave Courbet, *The Painter's Studio. A Real Allegory of a
Decisive Seven-Year Phase of my Artistic (and Moral) Life*,
oil on canvas, 1855, Paris, Musée d'Orsay © akg-images /
Erich Lessing

Page 135
Edouard Manet, *Le Bain (Le Dejeuner sur l'herbe)*, 1866,
Paris, Musée d'Orsay

Page 139
Claude Monet, *Impression, soleil levant*, 1872, oil on
canvas, Paris, © Musee Marmottan Monet, Paris, France /
Bridgeman Images

Chapter 8

Page 161
Edvard Munch, *The Scream (The Shriek of Nature),*
oil, tempera and pastel on board, 1893, Oslo,
National Gallery

Page 164
Pablo Picasso, *Guernica,* oil on canvas, 1947, Madrid,
Museo Nacional Centro de Arte Reina Sofia ©Succession
Picasso/DACS, London 2014

Page 167
The Joy of Life, 1905–6 (oil on canvas), Matisse, Henri
(1869–1954) / The Barnes Foundation, Philadelphia,
Pennsylvania, USA. Artwork: © 2014 Succession
H. Matisse/DACS, London. Digital image: Bridgeman
Images

Page 168
Umberto Boccioni, *Development of a Bottle in Space,*
bronze, 1913, New York, Metropolitan Museum of Art,
Bequest of Lydia Winston Malbin, 1989,
www.metmuseum.org

Page 171
Marcel Duchamp (1887–68), *Fountain,* glazed porcelain,
1917 (replica 1964), Tate, London 2014 © Succession Marcel
Duchamp/ADAGP, Paris and DACS, London 2014

Page 173
Salvador Dalí, *Corpus Hypercubus (Crucifixion),* oil on canvas, 1954, New York, Metropolitan Museum © Salvador Dali, Fundació Gala-Salvador Dalí, DACS, 2014. Digital image: IAM / akg-images

Page 175
Piet Mondrian, *Composition with Yellow, Red, Black, Blue and Grey,* oil on canvas, 1920, Amsterdam, Stedelijk Museum © akg-images

Page 176
Kasimir Malevich, *Black Square,* oil on canvas, 1915, Moscow, Tretyakov Gallery © Fine Art Images/Heritage Images/Getty Images

Page 179
Mark Rothko, *No. 14, 1960,* oil on canvas, San Francisco Museum of Modern Art, Helen Crocker Russell Fund purchase; ©1998 Kate Rothko Prizel & Christopher Rothko ARS, NY and DACS, London

Page 180
Jackson Pollock, *Autumn Rhythm No. 30,* paint on canvas, 1950, New York, Metropolitan Museum of Art © The Pollock-Krasner Foundation ARS, NY and DACS, London 2014

Page 182
Alexander Calder, *Mobile*, metal, wood, wire and string,
c.1932, Tate, London 2014, loan of Mary Trevelyan © 2014
Calder Foundation, New York / DACS London

Chapter 9

Page 188
Richard Hamilton, *Just what is it that makes today's
homes so different, so appealing?,* collage, 1956, Kunsthalle,
Tubingen, Germany / Bridgeman Images. © R. Hamilton.
All Rights Reserved, DACS 2014

Page 191
Andy Warhol, *Marilyn Diptych*, screen-print and acrylic
paint on canvas, 1962, Tate, London 2014 © 2014 The Andy
Warhol Foundation for the Visual Arts, Inc. / Artists
Rights Society (ARS), New York and DACS, London

Page 192
Claes Oldenburg and Coosje van Bruggen, *Dropped Cone*,
stainless and galvanised steels, fibre-reinforced plastic,
balsa wood, painted with polyester gelcoat, 1998–2001,
Cologne, Neumarkt Galerie © akg-images / Interfoto /
Walter Allgoewer

Page 193
Barbara Kruger, *Untitled (I shop therefore I am)*,
photographic silkscreen/vinyl, 1987, New York, Mary
Boone Gallery ©Barbara Kruger, Courtesy: Mary Boone
Gallery, New York

Page 194
Jenny Holzer, *Xenon for Venice (In the Night When No
Women Go About And)* Light Projection, 1999, Venice,
Fondazione Giorgio Cini. ©Jenny Holzer. ARS, NY
and DACS, London 2014. Digital image courtesy Jenny
Holzer/Art Resource, NY

Page 197
Yoko Ono performing Cut Piece, 1964, at Sogetsu Art
Centre, Tokyo, Japan. Photo by Minoru Hirata. Courtesy
of Yoko Ono

Page 199
Joseph Beuys, *I Like America and America Likes Me*,
performance with coyote, May 1974, New York, René Block
Gallery © DACS 2014

Page 200
Tracey Emin, *My Bed,* bed with sheet and pillows, clothing,
objects and carpet, 1998, London, Charles Saatchi Gallery
© Tracey Emin. All rights reserved, DACS 2014

Page 202
Cornelia Parker, *b.*1956, *Cold Dark Matter: an Exploded View,* wood and various materials, 1991 © Tate, London 2014/ Courtesy the artist and Frith Street Gallery, London

Page 205
Bill Viola, *Emergence*, 2002, Colour high-definition video rear projection on screen mounted on wall in dark room. Projected image size: 78 ¾ × 78 ¾ in (200 × 200 cm); room dimensions variable, 11:40 minutes. Performers: Weba Garretson, John Hay, Sarah Steben. Photo: Kira Perov

Page 206
Anselm Kiefer, *Nigredo,* 1984, oil, emulsion, shellac, straw and woodcut fragments on canvas, 130 × 218 ½ in. (330.2 × 555 cm) © Anselm Kiefer, Photo: Studio Kiefer, Courtesy White Cube / Philadelphia Museum of Art, Philadelphia

Page 208
Francis Bacon, *Study after Velázquez's Portrait of Pope Innocent X*, oil on canvas, 1953 (oil on canvas) / Private Collection / Bridgeman Images © The Estate of Francis Bacon. All rights reserved. DACS 2014

While every effort has been made to contact copyright-holders of illustrations, the author and publishers would be grateful for information about any illustrations where they have been unable to trace them, and would be glad to make amendments in further editions.

FURTHER
INVESTIGATIONS

A bibliography for the many periods, topics and artists discussed here would be unworkable. Some good bibliographies are available online, which allow the reader to follow up areas of particular interest. The two most useful are:

http://www.oxfordbibliographies.com/obo/page/
art-history

https://www.getty.edu/research/tools/bha/

IDEAS
IN
PROFILE

Ideas in Profile is a landmark series of enhanced eBooks and beautifully illustrated print books that offer concise, clear and entertaining introductions to topics that matter.

Each enhanced eBook will have animated sequences illustrated by Andrew Park and **COGNI+IVE**, the team behind the renowned RSA Animates.

Visit www.ideasinprofile.com to watch the animations and find out more.

ALREADY PUBLISHED

Politics
by David Runciman

FORTHCOMING

Shakespeare
by Paul Edmondson

Social Theory
by William Outhwaite

The Ancient World
by Jerry Toner

Criticism
by Catherine Belsey